English Translation of Classical Chinese Calligraphy Masterpieces

英譯法書

KS Vincent POON (潘君尚)
BSc, CMF, BEd, MSc

Kwok Kin POON (潘國鍵)
BA, DipEd, MA, MPhil, MEd, PhD

The SenSeis

First Edition
Jan 2019

Published by
The SenSeis 尚尚齋
Toronto
Canada
www.thesenseis.com
publishing@thesenseis.com

ISBN 978-1-7753221-1-5

滾滾長江東逝水，浪花淘盡英雄。是非成敗轉頭空。青山依舊在，幾度夕陽紅。

白髮漁樵江渚上，慣看秋月春風。一壺濁酒喜相逢。古今多少事，都付笑談中。

楊慎臨江仙 二千十六年仲夏 洪靈為士於多倫多

KS Vincent Poon's calligraphy of
Yang Shen's *The Immortals by the River* (楊慎臨江仙)

KS Vincent Poon's model of Wang Xizhi's (王羲之)
Shi De Shu Tie (適得書帖), *Zhi Yu Dong Tie* (知欲東帖), *Cha Liang Tie* (差涼帖)

Table of Contents

Chapter Four:

A Poem on General Pei (裴將軍帖)

Chapter Five:

Huai Su's Autobiography (懷素自叙帖)

INTRODUCTION

KS Vincent Poon's model of Wang Xizhi's (王羲之)
Dan Xi Tie (且夕帖) and *Fu Xiang Tie* (伏想帖)

English Translation of Classical Chinese Calligraphy Masterpieces

Introduction

(I)

One major area in traditional Chinese culture is the art of Chinese calligraphy. Unfortunately, Chinese calligraphy is often misunderstood to be merely a pursuit to scribe pretty Chinese characters. Unbeknownst to many, mastering the art actually requires one to cultivate one's temperament in additional to being technically adept. Indeed, the art of Chinese calligraphy was long ago recognized to be "a testament to one's moral character"[1], "an expression of one's inner emotions"[2], and an art that requires seamless coordination between the hands and mind[3]. Hence, Chinese calligraphy in the Tang Dynasty was accordingly described as *shudao/shodo* "書道 (a pursuit towards enlightenment via the path of studying calligraphy)" rather than *shufa* "書法 (methods and techniques in scribing calligraphy)"[4]. In fact, the influential *A Narrative on Calligraphy* (or *Shu Pu*, 書譜) written by Tang Dynasty's Sun Guoting (孫過庭) largely focused on discussing personal temperaments in scribing calligraphy rather than individual calligraphic techniques.[5]

 As such, to fully appreciate a masterpiece of Chinese calligraphy (often known as "法書", which refers to an outstanding and exemplary work that is worth for all to study and observe), aside from examining its apparent aesthetics, one must also consider the overall manner expressed in the work, the personal background of the calligrapher, its textual content, as well as the historical and cultural context in which it was written.

5

(II)

Sadly, there are currently no satisfactory English translations of prominent classical Chinese calligraphy masterpieces such as *Cao Quan Stele* (曹全碑), *Lanting Xu* (蘭亭帖) and *Huai Su's Autobiography* (懷素自叙帖). For instance, Patricia Ebrey's English translation of *Cao Quan Stele* possesses numerous misinterpretations[6], and even renowned translator Lin Yutang's (林語堂, 1895-1976) translation of *Lanting Xu* contains significant errors and omissions that can lead to a great deal of misunderstanding of the original text[7]. It is therefore exceedingly difficult for English speakers to fully appreciate the wonders of these masterpieces as they cannot completely and accurately comprehend the scribed texts and their cultural implications. The present book shall provide readers with precise, annotated, line-by-line and high fidelity English translations of five classical Chinese calligraphy masterpieces. Translations are accompanied by brief historical backgrounds of the artworks as well as comments and footnotes to guide readers to better understand their values and cultural significances. The five selected masterpieces are:

1. *Cao Quan Stele* (曹全碑) by an unknown calligrapher (185AD);
2. *Lanting Xu* (蘭亭帖) by Wang Xizhi (王羲之, 303-361AD);
3. *Elaborations on the Chronicle of Ni Kuan* (倪寬贊帖) by Chu Suiliang (褚遂良, 596-658AD);
4. *A Poem on General Pei* (裴將軍帖) by Yan Zhenqing (顏真卿, 709-785AD);
5. *Huai Su's Autobiography* (懷素自叙帖) by Huai Su (懷素, 725-785 AD or 737-799 AD).

It is my sincere hope that this book can help English speakers to resonate with and wholly appreciate the wonders of these great works.

KS Vincent Poon
Jan 2019

Footnotes

(1). KS Vincent Poon & Kwok Kin Poon, *A Narrative on Calligraphy by Sun Guoting* 英譯書譜. Toronto: The SenSeis, 2018, p.25, Line102, "驗燥濕之殊節，千古依然".

(2). Ibid, p.25, Line 101, "故可達其情性，形其哀樂".

(3). Ibid, p.53, Line 257, "無間心手".

(4). As indicated in 《中國書法大辭典》:

> 誠如唐虞世南《筆髓論》所言：「故知書道玄妙，必資神遇，不可以力求也。」明董其昌《畫禪室隨筆》卷一《評書法》曰：「總之欲造極處，使精神不可廢沒。所謂神品，以吾神能著故也。何獨書道，凡事皆爾。」清包世臣《藝舟雙楫》·「書道妙在性情，能在形質。」皆主張以人之質爲書之本。「書道」一詞，起源甚早，唐人論書著作中多見之。

As mentioned by renowned Tang Dynasty Calligrapher Yu Shinan, "to grasp the essence of *shudao/shodo* (書道), one must perceive and understand it in the mind but not by brute physical force." Ming Dynasty's Dong Qichang also wrote, "at the highest level (of calligraphy), one's spirit must not be absent. To create an outstanding piece of calligraphy, one must inject one's mind and soul into the work and write with one's heart. This philosophy is certainly not exclusively restricted to *shudao/shodo* (書道) but applies to everything else that we do." Qing Dynasty's Bao Shichen wrote, "the essence and ingenuity of *shudao/shodo* (書道) is temperament, while being capable to scribe well the exterior physical forms comes second." Hence, it is apparent that personal character and mind are fundamental to scribing calligraphy. The term *shudao/shodo* (書道) originated long time ago; it

is a term that is frequently seen in writings by people of the Tang Dynasty regarding Chinese calligraphy. (interpreted by KS Vincent Poon)
Source: 梁披雲主編,《中國書法大辭典》. 廣東: 廣東人民出版社 , 1991, p.73.

(5). See footnote (1).

(6). In "*Later Han Stone Inscriptions*" (*Harvard Journal of Asiatic Studies*, vol. 40, no. 2, 1980, pp. 325–353), Patricia Ebrey published an annotated English translation of *Cao Quan Stele* that contains numerous misinterpretations. The major misinterpretations are highlighted as follows:

i.) "效穀人也" was misinterpreted as "(Cao Quan) comes from Chiao-ku". This phrase should be interpreted as "(Cao Quan's) ancestral home (籍貫) was in the county of Xiaogu (效穀縣)". The phrase does not necessarily mean Cao Quan was physically born and came from there.

ii.) "既定爾勳 , 福祿攸同" was simply interpreted as "all shared in the benefits"; "既定爾勳" was omitted and not translated.

iii.) "甄極毖緯" was incorrectly interpreted as "looked in the abstruse and was attentive to details". "毖緯" is actually "讖緯之學", which refers to the study of various arts of prophesizing that are based on classical Chinese teachings.

iv.) "無文不綜" was incorrectly interpreted as "there being no written words he did not investigate". "綜" here should be "精通 (well versed with thorough and comprehensive understanding)" not "investigate".

v.) "易世載德 , 不隕其名" was erroneously interpreted as "Many generations will record his virtue; his name will not be lost". "載德" is absolutely not "record one's virtue" while "其名" here in

8

fact refers to the family name Cao not just Cao Quan.

vi.) "同僚服德" was incorrectly interpreted as "his colleague fell under the influence of his virtue". "服" here is certainly not "fell under the influence of".

vii.) "威牟諸賁" was incorrectly interpreted as "his stern demeanor stimulated the soldiers".

viii.) "咸蒙瘳悆" was incorrectly interpreted to carry the meaning of "[clothes] to keep them warm".

ix.) "鄉明而治" was incorrectly interpreted as "The villages became enlightened". "鄉" here is actually "嚮/向 (directed towards)". "嚮明而治" is in fact an idiom derived from *I Ching* (《易經》) and carries no meaning of "villages being enlightened".

x.) "升降揖讓朝覲之階" was incorrectly translated to "People were going up and down, bowing and giving way on the steps of the audience hall". "升降揖讓" should together be interpreted as the adjective of the main object "朝覲之階(steps/stairs of the audience hall)". "People" is absolutely not the main object of the phrase.

xi.) "懿明后，德義章" was erroneously interpreted as "His (Cao Quan) exceptional wisdom was ample; his virtue and propriety were manifest". "明后" is actually a common term describing the ruling Emperor while "懿" means "praise", and so "德義章" refers to the ruling Emperor's virtue and propriety being seen and shown to all. The entire sentence was hence written to proclaim the ruling Emperor not Cao Quan.

xii.) "闕嵯峨" was incorrectly interpreted as "To make a gap towards the peaks".

xiii.) "鄉明治，惠沾渥" was incorrectly interpreted as "The

countryside became enlightened and well ordered". Again, "鄉" here is "嚮/向 (directed towards)", see ix. Further, "惠沾渥" appeared to be omitted and not translated.

For the correct translations and further footnotes of all the above, please see *Chapter One: Cao Quan Stele*.

(7). In Lin Yutang's *The Importance of Understanding* 古文小品譯英 (Great Britain: Heinemann, 1961), he published his translation of *Lanting Xu* ("*At The Orchid Pavilion*", pp. 98-99). This translation contains significant omission and errors that are outlined as follows:

i.) "暎帶左右" was incorrectly translated as "catches the light to the right and to the left". "暎" is "映" and here should be interpreted as "相映(complemented by)" as seen in:

A. 范曄《後漢書·張衡傳》:
冠咢咢其映蓋兮，佩綝纚以輝煌。
李賢注：映蓋謂冠與車蓋相映也。
Source: 范曄《後漢書》張衡傳. 香港:中華書局, 1971, pp.1933-1934.

B. 高適《自淇涉黃河途中作十三首》:
山河相映帶，深淺未可測。
Source:《全唐詩》卷二百十二. 欽定四庫全書薈要集部全唐詩, 康熙四十六年版, pp.15-16.

ii.) "品類之盛" was inadequately translated as "throbbing with life", which carried no meaning of "the myriad diversity of biological life". Note, "品類之盛" is coupled with the previous sentence "宇宙之大 (the vast and great immensity of the Universe)".

iii.) "騁" in "騁懷" was incorrectly translated as "pleasing". "騁" is "放任/放縱(free/liberated without restraint", please see *Kangxi Dictionary* (《康熙字典》)"騁".

iv.) "俯仰一世" was incorrectly translated as "they let their thoughts travel to the past and the present". "俯仰" literally means "glancing up and down once" and is used here as a metaphor for "a very short time (迅疾, almost an instant)" as seen in the following examples:

A. 阮籍《詠懷》其三十二：
去此若俯仰，如何似九秋？
陳伯君注: 俯仰, 一俯一仰之間, 言迅疾也。
Source: 陳伯君校注《阮籍集校注》. 北京: 中華書局, 1987, pp. 310-311.

B. 王安石《送李屯田守桂陽》之一：
追思少時事，俯仰如一夕。
Source: 王安石《王臨川集》第二册 卷六. 上海: 商務印書館, 1928, p.36.

C. 王慎中《游白鹿洞》：
景物易流徙，今古同俯仰。
Source: 王慎中《遵巖先生文集》卷二. 明 隆慶五年版, p.5.

D. 紀曉嵐《閱微草堂筆記·灤陽消夏錄二》：
俯仰之傾，天已將曙。
Source: 紀曉嵐《閱微草堂筆記》. 上海: 上海春明書店, 出版年份缺, p.49.

"俯仰" hence carries no meaning of "let their thoughts travel" whatsoever.

v.) "暫得於己，快然自足" was insufficiently translated as "what he wants he is happy".

vi.) "不知老之將至" was erroneously translated as "never feels old".

vii.) "及其所之既惓, 情隨事遷, 感慨係之矣" was inadequately interpreted as "Then as time passes on and one is tired of his pursuit". "情隨事遷, 感慨係之矣" was completely omitted in Lin's

translation.

viii.) "猶不能不以之興懷" was mistranslated as "What a thought".

ix.) "死生亦大矣" was erroneously translated as "death as a great question"; the word "生(birth)" was completely omitted.

x.) "固知一死生為虛誕，齊彭殤為妄作" was poorly translated as "It is cool comfort to say that life and death are different phases of the same thing and that a long span of life or short life does not matter". To use "cool comfort" to represent both "虛誕(absurd)" and "妄作(ridiculous fabrication)" is utterly inappropriate and incorrect.

Such "creative treachery" in translation should be best avoided to eliminate misinterpretation among English speakers. For the correct translations and further footnotes of all the above, please see *Chapter Two: Lanting Xu*.

CHAPTER ONE:

Cao Quan Stele

曹全碑

KS Vincent Poon's model of Wang Xizhi's (王羲之)
Zhan Ji Hu Tao Tie (旃罽胡桃帖) and *Qiu Zhong Tie* (秋中帖)

Chapter One:

Cao Quan Stele (曹全碑)

Historical Background

(I)

Cao Quan Stele (曹全碑) was made and installed in 185AD to commemorate Cao Quan (曹全), a virtuous officer of the Eastern Han Dynasty. This stone stele was uncovered between 1573 to 1619 AD during the Ming Dynasty at the Heyang County of the Shaanxi Province (陝西郃陽).[1] Remarkably, the stele suffered minimal damage from the ages and, even up to now, most of its elegant inscribed characters remain intact and are clearly visible. It is hence today considered to be one of the most well-preserved Han clerical script (漢隸) works.[2] Further, the textual content chronicled various historical events in the late Eastern Han Dynasty and so is also regarded by some as an important primary source in studying the history of that period.[3]

(II)

The stele's calligraphy is renowned for its refinement, elegance, liveliness as well as vigor (秀美飛動, 遒秀逸致).[4] It was once said that its elegance greatly influenced and gave rise to the exquisite standard script styles written by subsequent renowned calligraphers such as Ouyang Xun and Chu Suiliang (下開魏、齊、周、隋及歐、褚諸家楷法).[5] Despite its beauty and importance, the identity of the calligrapher remains unknown. The actual stone stele is currently retained in Xian's Forest of Stone Steles (西安碑林), China.

Translation

1. 君諱全，字景完，敦煌效穀人也。其先蓋周之胄。
The Honorable Gentleman (君) had the first name given by his parents as Quan "全", which was forbidden from mentioning by ordinary people (諱)[6]. His "courtesy name" was Jingwan (景完). His ancestral home[7] was the county of Xiaogu (效穀縣), commandery of Dunhuang (敦煌郡). His ancestors were descendants of the Zhou imperial family.

2. 武王秉乾之機，翦伐殷商。
When King Wu of Zhou (周武王) grasped the opportunity offered by the Heavens (秉乾之機)[8], he conquered and eliminated the Shang Dynasty (殷商)[9].

3. 既定爾勳，福祿攸同。封弟叔振鐸於曹國，因氏焉。
As he determined the various meritorious deeds by the many (既定爾勳)[10], both fortune and land were shared among them (福祿攸同)[11]. King Wu of Zhou so then bestowed his younger brother Shu Zhen Duo (叔振鐸) the land of Cao (曹國), and thus Shu Zhen Duo took the surname Cao (因氏焉).

4. 秦漢之際，曹參夾輔王室。
Between the late Qin and early Han period, Cao Shen (曹參, an ancestor of Cao Qian) aided the Imperial family (ie. Han Emperor Gaozu, Liu Bang, 劉邦).

5. 世宗廓土斥竟，子孫遷于雍州之郊。分止右扶風，或在安定，或處武都，或居隴西，或家敦煌。枝分葉布，所在爲雄。
Han Emperor Shizong (世宗, which is Han Emperor Wu 漢武帝) expanded the nation's border, and the descendants of Cao relocated to Yongzhou (雍州) and its surrounding districts. They dispersed to and resided in areas such as Youfufeng (右扶風), Anding (安定), Wudu (武都), Longxi (隴西) and Dunhuang (敦煌). The Cao family continued to prosper and branched (枝分葉布) with each subfamily attaining great prominence within its residing territory (所在爲雄).

6. 君高祖父敏，舉孝廉，武威長史、巴郡胸忍令、張掖居延都尉。

The Honorable Gentleman's great-great-grandfather (高祖) was Cao Min (曹敏) who was nominated (舉) to public office for "Being Uncorrupted and A Role Model of Filial Piety" (孝廉)[12]. He was once the Chief Clerk of Wuwei (武威長史), the County Magistrate of Quren County of the Commandery of Ba (巴郡胸忍令), as well as the Commandant of Zhangye Juyan (張掖居延都尉).

7. 曾祖父述，孝廉，謁者、金城長史、夏陽令、蜀郡西部都尉。

His great-grandfather (曾祖父) was Cao Shu (曹述) who too was nominated to public office for "Being Uncorrupted and A Role Model of Filial Piety" (孝廉). He was once appointed to be an Imperial Messenger (謁者), the Chief Clerk of Jincheng (金城長史), the County Magistrate of Xiayang (夏陽令), as well as the West Region Commandant of the Commandery of Shu (蜀郡西部都尉)[13].

8. 祖父鳳，孝廉，張掖屬國都尉丞、右扶風隃麋侯相、金城西部都尉、北地太守。

His grandfather was Cao Feng (曹鳳) who was also nominated to public office for "Being Uncorrupted and A Role Model of Filial Piety" (孝廉). He was the Deputy Commandant of the Zhangye Vassal State (張掖屬國都尉丞), the Marquis-Chancellor of Shumi of the Commandery Youfufeng (右扶風隃麋侯相), the West Region Commandant of Jincheng (金城西部都尉), as well as the Governor of the Commandery of Beidi (北地太守).

9. 父璊，少貫名州郡。不幸早世，是以位不副德。

His father was Cao Beng (曹璊), whose name was widely known in several provinces and commanderies. Unfortunately, he died early and so his stature (位)[14] did not come to match (副)[15] his good deeds and cultured temperament (德)[16].

10. 君童齔好學，甄極毖緯，無文不綜。

The Honorable Gentleman was a motivated learner when he was a child. He extensively studied and could discern (甄)[17] the

various arts of prophesying that are based on classical teachings (慇緯)[18], and there was no literature in which he was not well-versed (無文不綜)[19].

11. 賢孝之性，根生於心。收養季祖母，供事繼母。

Filial piety was in his nature and rooted in his heart (賢孝之性，根生於心). He took care of the concubine(s) of his grandfather (收養季祖母) and tended to his stepmother(s) (供事繼母).

12. 先意承志，存亡之敬，禮無遺闕。

He could even anticipate the will of his parents and carried out their wishes without his parents' direct instructions (先意承志)[20]. As for paying deference to those who were alive and those who had perished, there was no rite that he had not followed or left undone (存亡之敬，禮無遺闕).

13. 是以鄉人為之諺曰：「重親致歡曹景完。」易世載德，不隕其名。

Hence, the people of his hometown often proclaimed: "All his parents and grandparents (重親)[21] were most pleased with Cao Jingwan." He and previous generations of Cao had acted virtuously like this as well as accomplished many good deeds (易世載德)[22], and so the family name and reputation had never fallen (不隕其名)[23].

14. 及其從政，清擬夷齊，直慕史魚。

When he was working as a civil servant, he was as pure and uncorrupted as Yi and Qi (夷齊)[24] and as honest and candor as Shi Yu (史魚)[25].

15. 歷郡右職，上計掾史; 仍辟涼州，常為治中、別駕。

He once held prestigious positions (右職) in various commanderies and was the Imperial Reporting Officer of Public Statistics (上計掾史)[26], and thus eventually he became an officer governing Liangzhou (仍辟涼州)[27], often carrying the titles of Officer of the Headquarters (治中) and Attendant Officer (別駕).

16. 紀綱萬里，朱紫不謬。

As he administered, he drew law and policy that were far and wide (紀綱萬里), and he never failed to distinguish what is right and what is wrong (朱紫不謬)[28].

17. 出典諸郡，彈枉糾邪，貪暴洗心; 同僚服德，遠近憚威。

As an officer delegated to take charge various commandries (出典諸郡), he impeached those who had violated the laws, righted wrongdoings (彈枉糾邪) and eliminated excessive greed and extravagance (貪暴洗心)[29]; his peers and colleagues all acknowledged and admired his good deeds, and so his might was dreaded with awe, far and near (同僚服德，遠近憚威).

18. 建寧二年，舉孝廉，除郎中，拜西域戊部司馬。時疏勒國王和德，弑父篡位，不供臧貢。

In the second year of Jingning (建寧二年, 169AD), he was nominated to public office for "Being Uncorrupted and A Role Model of Filial Piety" (孝廉) and was appointed Servant of the Palace (郎中) and Commander of the Wu Section of the Western Region (西域戊部司馬). At that time, the Emperor of the Kingdom of Shule (疏勒國), He De (和德), slew his own father[30] in attaining the thrown and refused to present tribute to Han (不供臧貢).

19. 君興師征討，有吮膿之仁，分醪之惠。攻城野戰，謀若涌泉;

He then raised his troops to subjugate He De (興師征討). He treated his troops with great benevolence (as benevolent as personally helping injured soldiers to drain the pus in their wounds, 吮膿之仁)[31] and generosity (as generous as sharing all his wine with the troops, 分醪之惠). As he struck cities and fought enemies in the open (攻城野戰), his plans and strategies were as diverse and fierce as a fountain with numerous streams of water violently gushing out of it (謀若涌泉);

20. 威牟諸賁，和德面縛歸死。還師振旅，諸國禮遺，且二百萬，悉以簿官。

his might was like (牟)[32] the legendary warriors Zhu and Bi (諸

賣)[33], and so He De surrendered (面縛)[34] and offered up his life (歸死). As he returned trumpeting his victory, various vassal nations presented tributes of close (且)[35] to two million, all of which were documented and reported to the public authorities (悉以簿官)[36].

21. 遷右扶風槐里令。遭同產弟憂，棄官。續遇禁网，潛隱家巷七年。
Afterwards, he was appointed as the County Magistrate of Huali (槐里) of the Commandery of Youfufeng (右扶風郡). Subsequently, however, his brother passed away (遭同產弟憂)[37] and he left public office (棄官). Further, he was entangled with the laws of prohibitions (續遇禁网)[38] and thus resorted to live in seclusion in his hometown for seven years (潛隱家巷七年).

22. 光和六年，復舉孝廉。七年三月，除郎中，拜酒泉祿福長。
In the sixth year of Guanghe (光和六年, 183AD), he was once again nominated to public office for "Being Uncorrupted and A Role Model of Filial Piety" (孝廉). In March of the seventh year of Guanghe (184AD), he was appointed Servant of the Palace (郎中) and the District Magistrate of the County of Lufu of the Commandery of Jiuquan (酒泉祿福長).

23. 訞賊張角起兵，幽、冀、兖、豫、荊、楊同時並動。而縣民郭家等復造逆亂，燔燒城寺。萬民騷擾，人懷不安。三郡告急，羽檄仍至。
That year, the heinous felon (訞賊) Zhang Jue (張角) rebelled and mobilized his troops, and the provinces of You (幽), Ji (冀), Yan (兖), Yu (豫), Jing (荊), and Yang (楊) were simultaneously unsettled (同時並動). As well, the county's Guo family and the likes revolted against the administration (而縣民郭家等復造逆亂), burning government offices in the cities (燔燒城寺)[39]. This distressed ten-thousands of civilians (萬民騷擾) and so everyone was not at peace (人懷不安). Numerous commanderies declared emergency and asked for help (三郡告急)[40], and urgent official communiques endlessly arrived to the Emperor (羽檄仍至)[41].

24. 于時聖主諮諏，群僚咸曰：君哉！轉拜郃陽令。收合餘燼，芟夷殘迸，絕其本根。

Thus, at that time, His Majesty sought for advice (聖主諮諏) and all his ministers exclaimed (群僚咸曰) : "Certainly him(君哉)!" He was thus transferred and appointed as County Magistrate of He-yang (轉拜郃陽令); he then took in the remaining rebellious embers (收合餘燼), wiped out the remnant fleeing rebels (芟夷殘迸), and worked to eliminate the insurgent's roots and foundations (絕其本根).

25. 遂訪故老, 商量僎艾王敞、王畢等。恤民之要，存慰高年，撫育鰥寡。以家錢糴米粟，賜癃盲。

Next, he visited the county's virtuous elders (故老) and consulted with venerable individuals (僎艾) such as Wang Chang (王敞), Wang Bi (王畢) and the likes. He also empathized with the needs of civilians (恤民之要), comforted the elderly (存慰高年), and tended to those who were widowed (撫育鰥寡). He even used his own money to purchase grains and rice and gifted them to those who were sick (癃)[42] and blind.

26. 大女桃斐等，合七首藥神明膏，親至離亭。部吏王皋、程橫等，賦與有疾者。咸蒙瘳悛。

His eldest daughter Tao Fei (桃斐), and others, concocted (合)[43] the "Medicine of Qi Shou (七首藥)"[44] and the "Cream of Deities (神明膏)". She personally delivered them (親至) to the lodgings for travelers that were near transportation facilities (離亭)[45]. Local officials such as Wang Gao (王皋) and Cheng Heng (程橫) then distributed them to the sick (賦與有疾者), and thus all were blessed (咸蒙)[46] to have their conditions improved and diseases cured (瘳悛)[47].

27. 惠政之流，甚於置郵。百姓繦負，反者如雲。

His rule of benevolence spread faster than the speed of couriers riding on horses to deliver messages (惠政之流，甚於置郵). Civilians carrying their belongings on their backs and returning to their

21

homes were as many as the clouds in the sky (百姓繦負，反者如雲)[48].

28. 戢治廧屋，市肆列陳。風雨時節，歲獲豐年。農夫織婦，百工戴恩。

He collectively (戢)[49] repaired and restored (治)[50] walls and houses (廧屋), and the markets became organized and orderly (市肆列陳). Favorable weather of winds and rains in all seasons had led to good harvest yields every year (風雨時節，歲獲豐年). Men who farmed, women who weaved, along with many other workers, were all grateful for his deeds and kindness (農夫織婦，百工戴恩).

29. 縣前以河平元年遭白茅谷水災害，退於戍亥之閒。興造城郭。

The county (縣), in the past, during the first year of Heping (河平元年, 28BC), had suffered from "The Floods of the Bai Mao Hill (遭白茅谷水災害)"; the waters had only receded between the years of Xu and Hai (戍亥 means 戊戌己亥 which is 23BC-22BC)[51]. The inner and outer city walls were so then constructed (興造城郭).

30. 是後舊姓及脩身之士，官位不登。君乃閔縉紳之徒不濟，開南寺門，承望華嶽。鄉明而治。

Thereafter, members of historically well-known families (舊姓)[52] and those who refined themselves were unable to elevate to public office (官位不登). He took pity on the lack of success among those of the gentries (君乃閔縉紳之徒不濟) and so removed the southern gate of the government office (開南寺門)[53] to catch and embrace the magnificent scenery of Mount Hua from within (承望華嶽)[54]. Such allowed him to administer the government towards the direction of brightness (鄉明而治)[55].

31. 庶使學者李儒、欒規、程寅等，各獲人爵之報。

This perhaps (庶) resulted in (使) scholars such as Li Ru (李儒), Luan Gui (欒規), Cheng Yin (程寅) and the likes to each receive rewards of honorable government official titles.

32. 廓廣聽事官舍、廷曹廊閣、升降揖讓朝覲之階。費不出民，役不干時。

Further, he expanded the administrative (聽事) offices and halls of the bureau (官舍), the corridors and the side-doors (廊閣) to various local government departments (廷曹), as well as the ascending and descending staircases for civilians to meet government officials with respect and deference (揖讓朝覲). These improvements did not tax nor cost civilians (費不出民), and the associated laborious efforts were not in discord with the times (役不干時)[56].

33. 門下掾王敞、錄事掾王畢、主簿王歷、戶曹掾秦尚、功曹史王顓等，嘉慕奚斯考甫之美。乃共刊石紀功, 其辭曰：

Head of Staff (門下掾) Wang Chang (王敞), Head of Managing Affairs (錄事掾) Wang Bi (王畢), Master of Documents (主簿) Wang Li (王歷), Head of the Revenue Section (戶曹掾) Qin Shang (秦尚), Merit Evaluator (功曹史) Wang Wei (王顓), and others, in approval and following (嘉慕) the virtues (美) of Xi Si (奚斯) and Kao Fu (考甫) in glorifying their sovereigns[57], are hence together here to have this stone inscribed (共刊石) to document his accomplishments (紀功) in a verse as follows (其辭曰):

34. 懿明后，德義章。貢王庭，征鬼方。威布烈，安殊方。

Praise to the wise Emperor (懿明后)[58], honor high His benevolence and righteousness so that they can been seen and shown to all (德義章). He (Cao Quan) was nominated to elevate into the Imperial court (貢王庭)[59] and conquered the alien land (征鬼方). His might was everywhere and prominent (威布烈) as he pacified the foreign (殊) desolated soil (方)[60].

35. 還師旅，臨槐里。感孔懷，赴喪紀。嗟逆賊，燔城市。

When he returned victorious with his troops (還師旅), he governed(臨) Huali (槐里). He thought fondly of his brother (感孔懷)[61] and quickly engaged in his funeral ceremony (赴喪紀). He sighed at the appearance of rebels (嗟逆賊) as well as their burn-

ing of cities (燔城市).

36. 特受命，理殘圮。芟不臣，寧黔首。

He was then specifically appointed (特受命) and subsequently dealt with the ravaged ruins (理殘圮). He weeded out those who were not submissive (芟不臣)[62] while bringing peace to the civilians (寧黔首)[63].

37. 繕官寺，開南門。闞嵯峨，望華山。鄉明治，惠沾渥。

He restored and improved the government office (繕官寺) as well as removed its southern gate (開南門) so that the office can watch far and wide over the high cliffs (闞嵯峨)[64] and observe Mount Hua (望華山). He administered the government towards the direction of brightness (鄉明治)[65] and brought about much benevolence (惠) so that civilians benefited greatly (沾渥)[66].

38. 吏樂政，民給足。君高升，極鼎足！

Officials were happy to administrate (吏樂政), while civilians were affluent and their needs well satisfied (民給足)[67]. Hence, he should be elevated (君高升) to the top position as high as the Three Chief Ministers (極鼎足)[68]!

39. 中平二年十月丙辰造。

Made in the second year of Zhongping, month of October, day of Bingchen (ie. October 1st, 185AD in Gregorian Calendar).

Footnotes

(1). 劉正成編,《中國書法鑒賞大辭典》。 北京: 大地出版社 , 1989 , p.116。

(2).《漢曹全碑》, 歷代法書選輯。 高雄: 大衆書局, 1973, p.51。

(3). See a) Patricia Ebrey, "*Later Han Stone Inscriptions*", *Harvard Journal of Asiatic Studies*, vol. 40, no. 2, 1980, pp. 325–353 ; b) Édouard Chavannes, "*Les pays d'Occident d'après le Heou Han chou*", *T'oung pao*, vol. 8, 1907, pp. 206-207.

(4). 萬經云：「秀美飛動，不束縛，不馳驟，洵神品也。」 孫承澤云：「字法遒秀逸致，翩翩與《禮器碑》前後輝映, 漢石中至寶也。」見劉正成編《中國書法鑒賞大辭典》。 北京: 大地出版社 , 1989 , p.116。

(5). 方朔《枕經堂金石書畫題跋》：「正文與碑陰為一手，上接《石鼓》，旁通章草，下開魏、齊、周、隋及歐、褚諸家技法，實為千古書家一大關鍵。」見劉正成 編《中國書法鑒賞大辭典》。 北京: 大地出版社 , 1989 , p.116。

(6). "諱" means "the honorable one's given name that is forbidden from mentioning by ordinary people". It is a custom and tradition in traditional Chinese culture to not call one's given name directly, except for those who are more junior than you.

(7). "敦煌效穀人也" meant "Cao Quan's ancestral home (籍貫) was in the county of Xiaogu (效穀縣), commandery of Dunhuang (敦煌郡)". The sentence does not necessarily mean Cao Quan was physically born there.

(8). "乾" here means "天(Heavens)", please see *Kangxi Dictionary* (《康熙字典》) "乾".

(9). "殷商" refers to "商朝 (Shang Dynasty, 1600-1046BC)".

(10). "爾" here means "彼/此(those/the many)" while "勳" refers to "大功勞(magnificent accomplishment)", see 中央研究院 《搜詞尋字》.

(11). "祿"is "封邑 (bestowing land)" , see 中央研究院 《搜詞尋字》.

(12). "孝廉" was the system of nominating and appointing individuals who were known to be uncorrupted (廉) and role models of filial piety (孝); local administrators were asked to recommend such individuals for Imperial consideration and appointment to public office. The system originated during the reign of Han Emperor Wu (漢武帝) but was later completely abolished and replaced by the Imperial Examination System (科舉) in the Tang Dynasty.

(13). "蜀郡西部都尉" should be interpreted as "西部都尉(West Region Commandant)" of "蜀郡(Commandry Shu)" for "西部都尉" together was an official title in Han Dynasty:

時西部都尉宰壘行太守事。
Source: 范曄《後漢書》卷八十一獨行列傳. 香港:中華書局, 1971, p.2674.

西部都尉廣漢鄭純為政清絜。
Source: 范曄《後漢書》卷八十六南蠻西南夷列傳. 香港:中華書局, 1971, p.2851.

As such, it is incorrect to interpret "蜀郡西部都尉" as "Commandant (都尉) of the West Region of the Commandry of Shu (蜀郡西部)".

(14). "位" here means "職位/官爵 (position/titles, ie. social status)" , see 中央研究院 《搜詞尋字》.

(15). "副" here means "相稱/符合(match/consistent)" , see 中央研

究院《搜詞尋字》.

(16). "德" here means "品行/節操 (one's deeds and conducts/temperament)", see 中央研究院《搜詞尋字》.

(17). "甄" here means "考察/識別 (study/discern)", see 中央研究院《搜詞尋字》.

(18). "毖緯" is "讖緯之學" which refers to the study of various arts of prophesying that are based on classical Chinese teachings. For details, see《經義考》卷二百六十三 至 二百六十七, 欽定四庫全書史部經義考, 乾隆四十六年版.

(19). "綜" here means "精通 (well versed with thorough and comprehensive understanding)", see 中央研究院《搜詞尋字》.

(20). "先意承志" originates from the *Book of Rites - Meaning of Sacrifices* (《禮記·祭義》):

> 君子之所為孝者, 先意承志 , 諭父母於道。
> What the superior man calls filial piety requires the anticipation of our parents' wishes, the carrying out of their aims and their instruction in the path (of duty).
> -translated by James Legge in *Sacred Books of the East.*

(21). "重親" here is "祖父母與父母的并稱 (a term that refers to one's parents and grandparents collectively)", see 中華民國教育部《重編國語辭典修訂本》.

(22). "易" here should be interpreted as "亦" and is tantamount to "奕" which here means "累世(generations)", see *Kangxi Dictionary* (《康熙字典》). Further, "載德" means "積德(accomplishing and accumulating good deeds)" as seen in:

I. *Records of the Grand Historian - Annals of Zhou* (《史記·周本紀》):

奕世載德，不忝前人。
Source: 司馬遷《史記》卷四周本紀. 香港: 廣智書局, 出版年份缺,
p.15.

II. *Book of the Later Han - The Biography of Yang Zhen* (《後漢書·楊震傳》) :

遂累葉載德，繼踵宰相。
李賢注引《易》曰：「德積載。」載，重也。
Source: 范曄《後漢書》卷五十四 楊震傳. 香港:中華書局, 1971,
p.1791.

(23). "隕" here means "墜(downfall/fallen)" , please see *Kangxi Dictionary* (《康熙字典》)"隕".

(24). "夷齊" refers to "伯夷(Bo Yi)" and "叔齊(Shu Qi)" who both were renowned for their integrity and nobility in Chinese history. For further reading, please see *Records of the Grand Historian – Volume 61 - Biography of Bo Yi* (《史記》卷六十一 伯夷列傳).

(25). 史魚(Shi Yu) was a historical figure who was renowned for his candor and sincerity as indicated in *The Outer Commentary to the Book of Songs by Master Han* (《韓詩外傳》):

(史魚) 生以身諫，死以尸諫，可謂直矣!
(Shi Yu), when alive, he gave advice with his body; after death, he gave advice with his corpse; such was his candor and honesty!
(interpreted by KS Vincent Poon)
Source: 賴炎元 編《韓詩外傳今註今譯》. 台北: 商務印書館, 1979,
p.307.

(26). "上計" refers to the system by which local administrators reported statistics (such as amounts of grains, treasury, population, etc.) to the emperor.

(27). "仍" here means "乃/然後(hence/then)", while "辟" here can mean "官吏(public officer) "or "治理(govern)" , see 中央研究院《

搜詞尋字》.

(28). "朱紫" here is "比喻優劣、善惡、正邪等相對的兩方 (a metaphor used to contrast the superior and the inferior, the pleasant and the repulsive, or the good and the evil)" as seen in the *Book of the Later Han* (《後漢書》) :

朱紫同色，清濁不分。
Source: 范曄《後漢書》卷六一左雄傳. 香港:中華書局, 1971, p.2017.

(29). "洗心" here means "洗滌心胸，摒除惡念或雜念 (removing evil thoughts or clearing one's mind to purify one's heart and soul)" as in *I Ching - Xi Ci I* 《易經·繫辭上》 :

聖人以此洗心，退藏於密, 吉凶與民同患。
Source: 陳襄民《五經全譯·易經》繫辭上第十一章. 河南: 中州古籍出版社, 1993, p.229.

(30). The narrative regarding Hede (和得) and the Han's campaign against him recorded in the *Cao Quan Stele* differs significantly from the formal official historical document *Book of the Later Han - Treatise on the Western Regions* (《後漢書·西域傳》). First, Hede was documented in the *Book of the Later Han* as the paternal uncle of King of Shule, not the father of King of Shule:

至靈帝建寧元年，疏勒王漢大都尉於獵中為其季父和得所射殺，和得自立為王。
Source: 范曄《後漢書》卷八十八西域傳. 香港:中華書局, 1971, p.2927.

Second, whereas the *Cao Quan Stele* described a triumphant victory against Hede (see line 20), the *Book of the Later Han* asserted the campaign against Hede was an unsuccessful one:

討疏勒，攻楨中城，四十餘日不能下，引去。其後疏勒王連相殺害，朝廷亦不能禁。

Source: 范曄《後漢書》卷八十八西域傳. 香港:中華書局, 1971, p.2927.

It is worth to note renowned sinologist Édouard Chavannes had recognized this discrepancy (see Édouard Chavannes, *"Les pays d'Occident d'après le Heou Han chou". T'oung pao*, vol. 8, 1907, pp. 206-207). However, his arguments were only based on his translation of Qing Dynasty's 《金石錄補》, a secondary source, not the original *Cao Quan Stele* text presented in this book.

(31). "㲒" is "沇" , see *Kangxi Dictionary* (《康熙字典》) "㲒", which here means "流/(let flow, drain)". The original character in the stele is certainly not "吮" as some contended.

(32). "牟" here is "侔" which means "similar" or "like" , see 中華民國教育部《重編國語辭典修訂本》.

(33). "諸賁" refers to the ancient brave warriors Zhuan Zhu (專諸) and Meng Bi (孟賁) as suggested in the *Book of Han-The Biographies of Kings of Huainan, Hengshan and Jibei* (《漢書·淮南衡山濟北王傳》):

> 棄南面之位，奮諸、賁之勇，常出入危亡之路。
> 顏師古注引應劭曰：吳專諸，衛孟賁也。
> Source: 班固 《漢書》卷四十四淮南衡山濟北王傳. 香港: 中華書
> 局,1970, pp.2138-2139.

(34). "面縛" literally means "both hands tied to the back while one faces the front (雙手被反綁在背後而面向前)" and is used as a metaphor for surrendering, see 中華民國教育部《重編國語辭典修訂本》.

(35). "且" here means "近(close to)" , see 中央研究院《搜詞尋字》.

(36). "簿" here represents "造冊登記(record, account and register)", whereas "官" refers to "公 (the public)" which contrasts "私 (self)" as in the *Book of Han* (《漢書》) :

五帝官天下，三王家天下。家以傳子，宜以傳賢。
司馬貞《史記索隱》注云：官，猶公也，謂不私也。
Source: 司馬貞《史記索隱》卷四. 欽定四庫全書史部史記索隱, 乾隆四十六年版, p.1.

Hence, "簿官" should be interpreted as "record, account and registered to the public authorities" as seen in *History of the Southern Dynasties* 《南史》:

時盜發桓溫冢，大獲寶物，客竊取以遺山圖。山圖不受，簿以還官。
Source: 李延壽《南史》卷四十六周山圖列傳. 北京: 中華書局, 1975, p.1156.

(37). "憂" here means "居喪(to observe the rites and funeral arrangements for a family member that had passed away)", please see *Kangxi Dictionary* (《康熙字典》)"憂".

(38). "网" is the ancient form of "罔". "遇禁网(Entangled with the laws of prohibition) " likely referred to the late Eastern Han's political turmoil commonly known as "黨錮之獄(The Imprisonment and Detainment of the Gang of Scholars and Bureaucrats)".

(39). "寺" here is "府廷(government office)", please see *Kangxi Dictionary* (《康熙字典》)"寺".

(40). "三" here does not necessarily mean "three"; "三" could mean "多數或多次(many/multiple)" as in "三思者，言思之多，能審慎也", see 中央研究院《搜詞尋字》.

(41). "羽檄" refers to "軍中緊急的文書(urgent military communique)", see 中華民國教育部《重編國語辭典修訂本》.

(42). "癃" means "老也, 病也 (elderly, sick)", please see *Kangxi*

Dictionary (《康熙字典》)"癃".

(43). "合" here means "配(concocted)", please see *Kangxi Dictionary* (《康熙字典》)"合".

(44). While some speculate "七" is "匕", the original character engraved in the stele is absolutely "七" not "匕".

(45). "離" means "departing". "亭" is "行旅宿會之所館也(lodgings for travelers)", please see *Kangxi Dictionary* (《康熙字典》)"亭".

Collectively, "離亭" refers to the lodging (亭) where people say goodbye to departing (別離) travelers as implicated in:

> I. 袁康 《越絕書》 外傳春申君:
> 明日,辭春申君:「才人有遠道客,請歸待之。」春申君果問:「汝家何等遠道客?」對曰:「圍有女弟,魯相聞之,使使求之。」... 春申君曰:「可得見乎?明日,使待於離亭。」
> Source: 《越絕書》卷十四. 欽定四庫全書史部越絕書,乾隆四十六年版, p. 1.

> II. 徐昌圖 《臨江仙·飲散離亭》:「飲散離亭西去,浮生長恨飄蓬。」
> Source: 張高寬等編《宋詞大辭典》. 瀋陽:遼寧人民出版社, 1990, p.232.

"離亭" was likely in or near a postal relay station (驛) of the national transportation network.

(46). "咸" here means "悉(all/completely)" , please see *Kangxi Dictionary* (《康熙字典》)"咸".

"蒙" here is "敬詞;受到(blessed to have received)" , see 中央研究院 《搜詞尋字》.

(47). "瘳" here is "疾病瘉也(recovered from a disease)", please see *Kangxi Dictionary* (《康熙字典》)"瘳".

"悛" here means "止也, 改也 (ceased and improved)", please see *Kangxi Dictionary* (《康熙字典》) "悛".

(48). "反" here means "回還(return)" as indicated in the *Book of Han – Biography of Chen Sheng* (《漢書·陳勝傳》):

使者五反。
顏師古注：反，謂回還也。
Source: 班固 《漢書》卷三十一陳勝項籍傳. 香港: 中華書局,1970, pp.1791-1792.

(49). "戢" means "斂(gather/collect)" as indicated in *Kangxi Dictionary* (《康熙字典》) "戢" and in *The Works of Mencius - Liang Hui Wang II* (《孟子·梁惠王下》):

思戢用光。
That he might gather his people together, and glorify his State.
-translated by James Legge in *The Works of Mencius*.
Source: 朱熹 《四書集註》 孟子梁惠王下，上孟卷一. 香港: 太平書局，1968，p. 23.

(50). "治" here means "整治；修治 (repair/restore)"，see 中央研究院 《搜詞尋字》.

(51). "戌亥" refers to the year "戊戌己亥"，which is 23-22BC.

(52). "舊姓" here is "families that are historically well-known" as seen in the annotations by Pei Songzhi (裴松之) in *Records of the Three Kingdoms – Book of Wei- Biography of Dong Zhuo* (《三國志·魏志·董卓傳》):

天子以謁者僕射皇甫酈涼州舊姓, 有專對之才...。
Source: 陳壽 《三國志》, 裴松之注, 魏志卷六董卓傳. 臺北: 中華書局,1968, p.9b.

(53). "開" in this context is "解除(remove/clear away)"，see 中央研究院 《搜詞尋字》.

(54). "承望" here means "迎合(cater to/catch and embrace)" as in *Book of the Later Han - Biography of Bao Yong* (《後漢書·鮑永列傳》):

都尉路平承望風旨，規欲害永。

Commandant Lu Ping <u>embraced</u> the wish (of Wang Meng, 王莽), and so planned to have Wing murdered.

(interpreted by KS Vincent Poon)

Source: 范曄《後漢書》卷二十九鮑永列傳. 香港:中華書局, 1971, p.1017.

(55). "鄉" here is "嚮/向 (directed towards)", please see *Kangxi Dictionary* (《康熙字典》)"向". Hence, "鄉明而治" is "嚮明而治"; "嚮明而治" is an established and commonly known phrase originating from *I Ching - Treatise of Remarks on Trigrams* (《易·說卦》):

聖人南面而聽天下，<u>嚮明而治</u>。

The sages turn their faces to the south when they give audience to all under the sky, <u>administering government towards the region of brightness.</u>

– translated by James Legge in *Sacred Books of the East*.

Source: 陳襄民《五經全譯·易經》說卦第五章. 河南: 中州古籍出版社, 1993, p.275.

Interestingly, the venerable Japanese Emperor Meiji's (明治天皇, 1852-1912AD) regnal title Meiji was also derived from this same phrase "<u>嚮明而治</u>", see 維新史料編纂事務局編《維新史》第五卷. 東京: 維新史料編纂事務局,昭和十六年 (1941), p. 369.

(56). "干時" here refers to "違反時勢(against/in discord with the times)" as suggested in the *Book of the Later Han – Biography of Yuan Shu* 《後漢書·袁術列傳》:

若陵僭無度，<u>干時</u>而動，眾之所棄，誰能興之！

Source: 范曄《後漢書》卷七十五袁術列傳. 香港:中華書局, 1971, p.2440.

(57). "奚斯(Xi Si)" was known for his accolades of his state Lu (魯) while "考甫(Kao Fu)" was renowned for his praises of his royal Yin Dynasty (殷, which is the Shang Dynasty) as indicated in the *Book of the Later Han – Biography of Cao Bao* (《後漢書·曹褒列傳》):

昔奚斯頌魯，考甫詠殷。 夫人臣依義顯君，竭忠彰主，行之美也。
In the past, Xi Si lauded his state Lu, and Kao Fu sang the praises of his dynasty Yin. Alas, when subordinates glorify their sovereigns according to righteousness and hold high their loyalties to exalt their rulers, their ways are certainly good and virtuous indeed.
(interpreted by KS Vincent Poon)
Source: 范曄《後漢書》卷三十五張曹鄭列傳. 香港:中華書局, 1971, p.1203.

(58). "懿" here means "(贊美)praise" as in the *Book of Han-Afterword and Family History I* (《漢書·敘傳上》):

懿前烈之純淑兮。
Source: 班固 《漢書》卷一百上敘傳上. 香港: 中華書局,1970, p.4213.

"明后" is a common term meaning "wise emperor/sovereign" as indicated in the *Classic of History* (《書經·太甲中》):

修厥身，允德協于下，惟明后。
孔傳: 言修其身，使信德合羣下，惟乃明君。
To cultivate his person, and by being sincerely virtuous, bring all below to harmonious concord with him; -this is the work of the intelligent sovereign.
–translated by James Legge in *The Chinese Classics*.
Source: 孔安國 《尚書孔傳》商書太甲中. 台北: 新興書局,1964, p.25.

(59). "貢" here is "上也, 薦也 (promote to)", please see *Kangxi Dictionary* (《康熙字典》)"貢".

(60). The original character "㠩" in the stele is another form of writing "荒", which means "desolated and barren grounds". Please see *Kangxi Dictionary* (《康熙字典》)"荒".

(61). "孔懷" is a term to describe "兄弟之情(the affection between two brothers)", see 中華民國教育部《重編國語辭典修訂本》.

(62). In this context, "臣" should be interpreted as "伏(obey/submit to)", please see *Kangxi Dictionary* (《康熙字典》)"臣".

(63). "黔首" is a term used to describe "黎民, 老百姓(ordinary laymen, civilians)", see 中華民國教育部《重編國語辭典修訂本》.

(64). "闕" here means "門觀也(observing by the watch tower at the gate or door)"; for further details please see *Kangxi Dictionary* (《康熙字典》)"闕".

"嵯峨" means "山勢高峻的樣子(the imposing manner of high and steep cliffs)" , see 中華民國教育部《重編國語辭典修訂本》.

(65). Please see footnote (55).

(66). "沾" here is "益也(benefited)", please see *Kangxi Dictionary* (《康熙字典》)"沾".

 "渥" here is "厚漬(greatly swamped with)", please see *Kangxi Dictionary* (《康熙字典》)"渥".

(67). "給足" means "豐富充裕，足供所需(affluent and with sufficient resources to meet the needs)" , see 中華民國教育部《重編國語辭典修訂本》.

(68). "極" here means "至也(reach to)", please see *Kangxi Dictionary* (《康熙字典》)"極".

"鼎足" alludes to "三公(The Three Chief Ministers)" in Chinese history as indicated in *Lun Heng – Exaggerations* (《論衡·語增》):

夫三公, 鼎足之臣, 王者之貞幹也 。

<u>As one of the three chief ministers</u>, a prop to the imperial tripod, he was the mainstay of the emperor.

Annotation: the sacrificial tripod was the emblem of royalty. The three ministers are likened to its three feet.

-translated and annotated by Alfred Forke in *Lun-heng*.

Source: 王充《論衡》卷七語增, 欽定四庫全書子部論衡, 乾隆四十三年版, p. 22b; & Alfred Forke, *Lun-heng, Part 1. Philosophical Essays of Wang Ch'ung.* Leipzig: TTO Harrassowitz, 1907, p.489.

Modelling of *Cao Quan Stele*
by KS Vincent Poon

錢糧未稟賜癉盲大女桃婴等合七首藥神明膏親至難亭部吏王罩程橫等

賑興有疾者咸蒙瘳悵惠政之流甚於首置郵百姓繦負反者如雷穀治廬屋布市

水决列陳風而退於成災官盛模豐政震年夫織婦百工姝患縣有叫河平元年遷乃閱菇宿繇

神爵之徙之報不消廣聽事官舍廷書廊閣外明而降揖讓朝覲學之階費橐不出民沒寅不干時

人爵之徙之報不消廣聽事官舍廷書廊閣外明而降揖讓朝覲學之階費橐不出民沒寅不干時

門下掾王敞錄事掾王畢主簿王庭戶曹掾秦尚功曹史王顈等嘉慕累斯芳

甫之美乃共刊石紀功其辭曰懿明后德義章貴王庭征鬼方婺布烈安殊威

還官寺開楗門關嵯峨赴逆薛色紀嘆逄賜燔城市特受命理戾尅坄芟不臣寧黔首

緒官寺開楗門關嵯峨望半山鄉明治惠沾遐夷樂政民給足君高升極鼎足

中平二年十月丙辰造

二千一百六千戌之家冬涉祥辉書已辟洲天為許行多作多為多高吁年二十六 〔印〕

Modelling of *Cao Quan Stele*
by KS Vincent Poon

君諱全，字景完，敦煌效穀人也。其先蓋周之冑，武王秉乾之機，翦伐殷商，既定爾勳，福祿攸同。封弟叔振鐸於曹國，因氏焉。秦漢之際，曹參夾輔王室。世宗廓土斥竟，子孫遷于雍州之郊，分止右扶風，或在安定，或處武都，或居隴西，或家敦煌。枝分葉布，所在為雄。

君高祖父敏，舉孝廉，武威長史、巴郡朐忍令、張掖居延都尉。曾祖父述，孝廉、謁者、金城長史、夏陽令、蜀郡西部都尉。祖父鳳，孝廉、張掖屬國都尉丞、右扶風隃麋侯相、金城西部都尉、北地太守。父琫，少貫名州郡，不幸早世，是以位不副德。

君童齔好學，甄極瑣緯，無文不綜。賢孝之性，根生於心，收養季祖母，供事繼母，先意承志，存亡之敬，禮無遺闕。是以鄉人為之諺曰：重親致歡曹景完。易世載德，不隕其名。及其從政，清擬夷齊，直慕史魚，歷郡右職，上計掾史，仍辟涼州，常為治中、別駕。紀綱萬里，朱紫不謬。出典諸郡，彈枉糾邪，貪暴洗心，同僚服德，遠近憚威。

建寧二年，舉孝廉，除郎中，拜西域戊部司馬。時疏勒國王和德，弒父篡位，不供職貢。君興師征討，有虔秉鉞，和德面縛歸死。還師振旅，諸國禮遺，且二百萬，悉以薄官。遷右扶風槐里令。遭同產弟憂，棄官。續遇禁網，潛隱家巷七年。光和六年，復舉孝廉。七年三月，除郎中，拜酒泉祿福長。

訞賊張角，起兵幽冀，兗豫荊楊，同時並動。而縣民郭家等，復造逆亂，燔燒城寺，萬民騷擾，人褱不安，三郡告急，羽檄仍至。本根遂訪故老商量，儁艾王敞、王畢等，恤其饑寒，慰其勞勤，存慰高年，撫育鰥寡，以口口口家。

CHAPTER TWO:

Lanting Xu

蘭亭帖

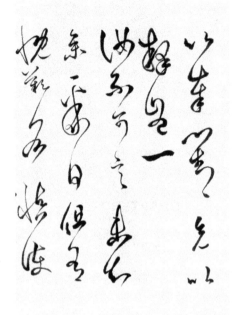

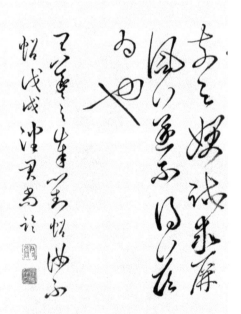

KS Vincent Poon's model of Wang Xizhi's (王羲之)
Feng Dui Tie (奉對帖) and *Ru Bu Tie* (汝不帖)

Chapter Two:

Lanting Xu (蘭亭帖)

Historical Background

(I)

Lanting Xu (蘭亭帖)[1], scribed by Wang Xizhi (王羲之, 303-361AD) in 353 AD, is considered to be the most beautiful semi-cursive script (行書) calligraphy ever written in Chinese history. The piece was so treasured that Tang Dynasty Emperor Taizong (唐太宗, 598-649 AD) was rumored to obtain the masterpiece deceitfully from a monk, ordered it to be traced and modelled, and then ultimately decreed to bury himself along with it in his tomb.[2] The original is long lost but models (臨摹搨本) of it by different renowned calligraphers can be found in museums across different parts of China, including Taiwan. One of the best models is the Shennong edition "神龍本" created by Tang Dynasty Feng Chengsu (馮承素, 617-672AD), who duplicated the original by outline-copying the form of each character (搨, 雙鉤廓填)[3]. This edition now resides in the Palace Museum in Beijing.

(II)

The literal content along with the aesthetics of the calligraphy are equally cherished in this masterpiece. The text was composed and scribed by Wang when he was in a gathering of forty-two re-nowned literati performing the Spring Purification Festival (修禊) in the ninth year of Yonghe (永和九年, 353 AD) at a place called Lanting (蘭亭, aka Orchid Pavilion).[4] During this gathering, the literati composed poems while engaged in a wine-drinking con-test: in the end, twenty-six literati composed thirty-seven po-ems[5], and Wang wrote *Lanting Xu* to commemorate this joyous event[6]. Wang first started by describing the time, place, and

43

weather of the gathering, then narrated the various events in the meeting, and finally concluded with an emotional lamentation on the perpetual frustrations in life. It was rumored that the original piece was penned by Wang when he was drunk, and when he sobered up the next day and attempted to reproduce the master-piece, he failed.[7]

(III)

Wang Xizhi is often considered to be the most outstanding Chinese calligrapher of all time. Born in 303AD in an upper-class aristocratic family, Wang Xizhi started learning Chinese calligraphy at the age of seven from the renowned calligrapher Wei Shuo (衛鑠 or 衛夫人, 272-349AD).[8] His father, Wang Kuang (王曠, ?-?AD), was a government prefecture chief (太守) and was also a calligrapher.[9] His uncle Wang Dao (王導, 276-339AD) was the prime minister (丞相) during the reign of Emperor Cheng of the Eastern Jin Dynasty (晉成帝, 321-342AD).[10]

At the age of twenty-two, Wang was first appointed to public office as an Assistant to the Palace Library (秘書郎). Wang was then subsequently promoted to Army Adviser (參軍), Chief Clerk (長史), Guardian General of the Army (護軍將軍), Interior Minister of Kuaiji (會稽內史), and eventually to General of the Right Army (右軍將軍) amid the internal political turmoil within the Eastern Jin Dynasty[11]. He wrote *Lanting Xu* in 353 AD when he was at the peak of his bureaucratic career. Two years afterwards, however, Wang resigned all his bureaucratic posts and vowed not return to public office ever again as he grew tired of political power struggles and was displeased with his superiors not following his many good pieces of advice.[12] That year he wrote another master-piece, *The Statement of Pledge* (告誓文).[13]

At the age of fifty-five, he narrated his own life as:

常依陸賈、班嗣、楊王孫之處世, 甚欲希風數子,老夫志
願盡於此也。 (14)

(I) often acted in accordance to the teachings of Lu
Jia (陸賈)(15), Ban Si (班嗣)(16), and Yang Wangsun
(楊王孫)(17), and have always desired to model my-
self on them; such is indeed wholly my aspiration in
life.

(interpreted by KS Vincent Poon)

Although Wang was frustrated with the outcome of his bureau-
cratic life, he found complete satisfaction with living by the prin-
ciples of Confucianism (as demonstrated by Lu Jia), Taoism (as
demonstrated by Ban Si), and the Way of Huang–Lao (黃老之術,
as demonstrated by Yang Wangsun). Indeed, his noble integrity,
refined temperament, as well as his outstanding calligraphic skills
had all come together to allow him to create superior and unri-
valed calligraphy that stood the test of time. Hence, he is cer-
tainly worthy to be regarded as "書聖 (The Sage of Calligraphy)"
in China and Japan.

Translation

1. 永和九年，歲在癸丑，暮春之初，
In the ninth year of Yonghe (353 AD), beginning of late spring,

2. 會于會稽山陰之蘭亭，脩禊事也。
we gathered at Lanting (蘭亭) in the county of Shanyin of the commandery of Kuaiji (會稽山陰)[18] to perform the Spring Purification Ceremony (修禊事)[19].

3. 羣賢畢至，少長咸集。
Many wise and talented ones, both young and old, all converged into one place.

4. 此地有崇山峻領，茂林脩竹。
The area was accompanied by high mountains (崇山峻領)[20] and steep hills as well as dense woods and tall bamboos.

5. 又有清流激湍，暎帶左右;
It was also surrounded and complimented (暎帶)[21] by a clear gushing stream (清流激湍) on both sides left and right;

6. 引以為流觴曲水，列坐其次。
these flowing waters were used to lead floating wine cups (流觴) into a winding canal (曲水) with all of us sitting beside it.[22]

7. 雖無絲竹管弦之盛，
Although there was no wonderful and grandiose (盛) instrumental music (絲竹管弦) to accompany us,

8. 一觴一詠，亦足以暢敘幽情。
drinking wines and reciting poems were more than enough to uplift us into unreserved, deep and tasteful exchanges (暢敘幽情).

9. 是日也，天朗氣清，惠風和暢。
That day, the skies were clear, and the air was fresh with a gentle

breeze.

10. 仰觀宇宙之大，
We looked upon the sky and admired the great immensity of the Universe,

11. 俯察品類之盛。
while we observed the ground in owe with the myriad diversity of Nature.

12. 所以遊目騁懷，
We indulged our eyes with these wonders as we liberated our minds,

13. 足以極視聽之娛，
and this was more than enough to satisfy and entertain all our visual and auditory senses,

14. 信可樂也。
indeed, this was truly a moment that could be cherished.

15. 夫人之相與，俯仰一世。
Alas, as friends associated with one another, a lifetime seemed to have passed in an instant (俯仰)[23].

16. 或取諸懷抱，悟言一室之內；
Some liked to express themselves (取諸懷抱) and engaged in earnest and unreserved dialogues (悟言) indoors;

17. 或因寄所託，放浪形骸之外。
while others identified themselves with their obsessions, unrestrained in their appearances and behaviors outdoors.

18. 雖趣舍萬殊，靜躁不同。
Although their choices were diversely different with some being more tranquil while others being more animated.

47

19. 當其欣於所遇，暫得於己，快然自足，

As they came upon anything that delighted them, they all found temporary (暫)[24] self-gratification, discontentedly satisfied (快然自足)[25],

20. 不知老之將至。

and had completely forgotten that they would all be turning old soon.

21. 及其所之既惓，

When they finally grew tired (惓)[26] of what delighted them,

22. 情隨事遷，感慨係之矣。

and their passions changed along (隨)[27] with the new circumstances, lamentations (感慨) would surely associate with (係)[28] that change indeed.

23. 向之所欣，俛仰之間，以為陳迹;

Obviously, the delights we once enjoyed disappear in split seconds (俛仰之間)[29] and shall then all become traces of the distant past;

24. 猶不能不以之興懷。

hence and similarly, even (猶)[30] the thought of all of the above can (不能不)[31] stir our emotions.

25. 況脩短隨化，終期於盡。

Let alone (況)[32] our lifespans, shorter or longer, are dictated by natural laws and that we shall all perish in due course.

26. 古人云：「死生亦大矣!」

Indeed, the wise from the past once said: "after all, birth and death are so immensely important!"[33]

27. 豈不痛哉？！

So how can we not be agonized about them?!

28. 每攬昔人興感之由，

Whenever I examine (攬)[34] the sentiments of those before us and the reasons behind their feelings,

29. 若合一契，

they are one and the same and consistent with what we feel today,

30. 未嘗不臨文嗟悼，不能喻之於懷。

I have not once (嘗)[35] studied their texts and authored my writings (臨文)[36] with no lamentation (嗟悼) and am unable to ease (喻)[37] my mind.

31. 固知一死生為虛誕，

Thus, of course, I know that it is absurd to equate life with death,

32. 齊彭殤為妄作。

and that drawing equivalence between the long-lived Peng Zu (彭祖)[38] and a baby who died at birth (殤)[39] is an utterly ridiculous fabrication.

33. 後之視今，亦由今之視昔，悲夫！

Our future generations will look upon us with the same sentiments as we look upon those before us, how sad indeed!

34. 故列敘時人，錄其所述。

Therefore, I am here to chronicle those who were present (時人) and record what they narrated during this gathering.

35. 雖世殊事異，所以興懷，其致一也。

Although times are different and circumstances may change, what stirs our emotions (所以興懷)[40] originates from one and the same source (致)[41].

36. 後之攬者，亦將有感於斯文。

Therefore, I am certain future readers shall resonate with my writing here.

Footnotes

(1). Also known as 蘭亭序, 蘭亭集序, 蘭亭叙, 臨河叙, 臨河序, etc.. For some traditional Chinese scholars, the piece is known as 蘭亭帖 (*Lanting Tie*) instead of 蘭亭序 *(Lanting Xu).*

(2). 張彥遠,《法書要錄》。 北京: 人民美術出版社, 1984, pp. 126-130。

(3). "搨" refers to "雙鉤廓填", which is a modelling technique wherein the contour of an original character is first traced to produce an outline; ink is then applied to fill it to produce an entire copy of that character. For further discussion on "搨" and the Shennong edition, please see 啟功 「蘭亭帖考」 in《啟功叢稿》. 北京: 中華書局, 1999, p.38.

(4). 房玄齡,《晉書》卷八十王羲之列傳。北京:中華書局 , 1974 , pp.2098-2099。

(5). 葉盛,《水東日記》。北京:中華書局 , 1980 , p.323。

(6).《晉書》 , p.2099. See (4).

(7).《法書要錄》, p.124. See (2).

(8). 李長路, 王玉池,《王羲之王獻之年表與東晉大事記》。重慶: 重慶出版社, 1992, p.6。

(9).《晉書》, p.2093, see (4). Also 陶宗儀,《書史會要》.上海: 上海書店, 1984, p.58。

(10).《晉書》, pp.181 & 2093, see (4).

(11). Ibid, p.2094, see (4).

(12). Ibid, pp.2100-2101, see (4).

(13). Ibid, p.2101, see (4).

(14). Ibid, p.2102, see (4).

(15). Lu Jia (陸賈, 240-170BC) was a renowned politician who once worked under Han Emperor Gaozu, Liu Bang (劉邦, 256-195BC). He acted as one of the counsellors who persuaded Emperor Gaozu to adopt Confucius teachings of benevolence and righteousness (仁義) in governing. According to Sima Qian's *Records of The Grand Historian* (《史記》):

陸生時時前說稱詩書。高帝罵之曰：「乃公居馬上而得之，安事詩書！」陸生曰：「居馬上得之，寧可以馬上治之乎？...秦任刑法不變，卒滅趙氏。鄉使秦已并天下，行仁義，法先聖，陛下安得而有之？」

Master Lu on numerous occasions expounded and praised the Book of Odes and the Book of Documents, until one day Gaozu began to rail him. "All I possess I have won on horseback!" said the emperor. "Why should I bother with the Odes and Documents?"
"Your Majesty may have won it on horseback, but can you rule it on horseback?" asked Master Lu... "Qin entrusted its future solely to punishment and law, without changing with the times, and thus eventually brought about the destruction of its ruling family (Zhao). If, after it had united the world under its rule, Qin had practised benevolence and righteousness and modeled its way upon the sages of antiquity, how would Your Majesty ever have been able to win possession of the empire?"
- translated by Burton Watson in *Records of The Grand Historian*.
Source: 司馬遷《史記》卷九十七酈生陸賈列傳. 香港: 廣智書局, 出版年份缺, p.74, & Burton Watson, *Records of The Grand Historian*. New York: Columbia University Press, 1961, pp.226-227.

(16). Ban Si (班嗣, ?-?) was a member of the renowned Ban family, see *Book of Han - Afterword and Family History I* (《漢書•敘傳上》). He was documented to have studied Confucianism yet cherished the ways of Laozi and Zhuangzi:

嗣雖修儒學，然貴老嚴(莊)之術 ... 曰：「若夫嚴(莊)子者，絕聖棄智，修生保真，清虛澹泊，歸之自然，獨師友造化，而不為世俗所役者也。」

Although Ban Si studied Confucianism, he cherished the ways of Laozi and Zhuangzi ... He once said, "As for a follower of Zhuangzi,

one should insulate oneself from the sages and leave one's wisdom behind, take care of oneself and preserve one's true nature, live simply with modesty, return oneself to Nature, and take Nature as the only teacher and friend so that one will not be enslaved by the mundane world."

(interpreted by KS Vincent Poon)

Source: 班固 《漢書》 卷一百上敘傳上. 香港: 中華書局,1970, p.4205.

(17). Yang Wangsun (楊王孫,?-?) was a follower of the "Way of Huang–Lao (黃老之術)". Accordingly to the *Book of Han*, Yang preferred his corpse to be buried naked so as to facilitate its return to its original true nature:

楊王孫者，孝武時人也。學黃老之術...及病且終，先令其子，曰：「吾欲贏葬，以反吾真，必亡易吾意。」

Source: 班固 《漢書》 卷六十七楊胡朱梅云傳. 香港: 中華書局, 1970, p.2907.

(18). "會稽山陰" is "會稽郡山陰縣 (commandery of Kuaiji, county of Shanyin)", currently in the province of Zhejiang (浙江省).

(19). "稧" is tantamount to "禊", please see *Kangxi Dictionary* (《康熙字典》)"稧".

(20). "領" is tantamount to "嶺(mountain)", please see *Kangxi Dictionary* (《康熙字典》)"領".

(21). "暎" is tantamount to "映", please see *Kangxi Dictionary* (《康熙字典》)"暎". "映" here means "相映(complemented by)" as in *Book of the Later Han - Biography of Zhang Heng* (《後漢書•張衡傳》)：

冠咢咢其暎蓋兮，佩綝纚以煇煌。
李賢注：暎蓋謂冠與車蓋相映也。
Source: 范曄 《後漢書》 卷五十六 張衡傳. 香港:中華書局, 1971, p.1933-1934.

"映" does not necessarily mean "照 (reflect)" in this context.

"帶" here means "圍繞(surrounded by)" as in *Strategies of the Warring States - Strategies of Chu I* (《戰國策•楚策一》) :

秦地半天下 , 兵敵四國 , 被山帶河 , 四塞以為固。
Chin's territory occupies half of all under Heaven, its army is sufficient to conquer surrounding nations, its land is isolated by mountains and surrounded by rivers, and so all of its borders are firmly consolidated. (interpreted by KS Vincent Poon)
Source: 臧勵龢選註《戰國策》楚, 張儀為秦破從連橫. 上海:商務印書館, 1933 , p.143.

(22). The literati engaged in a drinking contest wherein fully-filled wine cups were floated down a small winding stream: whenever a cup stopped in front of a participant, that person must compose a poem; otherwise, that person must empty the wine cup. See 李長路, 王玉池《王羲之王獻之年表與東晉大事記》. 重慶: 重慶出版社, 1992, p.21.

(23). "俯仰" literally means "glancing up and down once" and is used here as metaphor for "a very short time (almost an instant)".

(24). "蹔" is tantamount to "暫, please see *Kangxi Dictionary* (《康熙字典》)"蹔".

(25). Some contend "快然自足(discontentedly satisifed)" should actually be "快然自足(happily satisfied)" based on other literature like the *Book of Jin* (《晉書》). However, the character in the Feng Chengsu (馮承素) model (commonly known to be the most loyal to the original *Lanting Xu*) is clearly "快":

Further, renowned scholar 啟功 concluded "快" is written mistakenly as "怏" in the *Book of Jin*, see 啟功 「蘭亭帖考」in《啟功叢稿》. 北京: 中華書局, 1999, p.52 & p.56 footnote 5.

But then how does the phrase "怏然自足(discontentedly satisifed)" not be self-contradictory? If one examines the previous phrase "they all found temporary self-gratification (暫得於己)", then the subsequent phrase "怏然自足(discontentedly satisfied)" is actually reasonable: Wang was lamenting that the literati were only grudgingly enjoying such satisfaction as they all knew very well that such gratification would be transient and disappear in split seconds. Note further that "discontentedly satisfied" is consistent with Wang's subsequent assertions "情隨事遷，感慨係之矣" in Line 22 and "向之所欣，俛仰之間，以為陳跡" in Line 23.

(26). "惓" is tantamount to "倦", please see *Kangxi Dictionary* (《康熙字典》)"惓".

(27). "隨" is tantamount to "隨", see《漢典》.

(28). "係" here means "關聯(tied/associated with)", see 中央研究院《搜詞尋字》.

(29). "俛" is tantamount to "俯", please see *Kangxi Dictionary* (《康熙字典》)"俛".

"閒" is tantamount to "間", see 《漢典》.

(30). "猶" here carries the meaning of "尚且(even)", "因(hence)" and "同樣地(similarly)"，see 中央研究院《搜詞尋字》.

(31). The original text "不能不以" is a double negative sentence in Chinese which means "cannot not". For fluency, it is translated simply as "can" instead.

(32). "況" here means "何況(let alone)", see 中央研究院《搜詞尋

字》.

(33). "死生亦大矣" is a quote from Confucius in *Zhuangzi - Inner Chapters - The Seal of Virtue Complete* (莊子•內篇•德充符):

> 仲尼曰：「死生亦大矣，而不得與之變，雖天地覆墜，亦將不與之
> 遺。審乎無假而不與物遷，命物之化而守其宗也。」
> (Zhongni said,)'<u>Death and life are great considerations</u>, but they
> could work no change in him. Though heaven and earth were to be
> overturned and fall, they would occasion him no loss. His judgment
> is fixed regarding that in which there is no element of falsehood;
> and, while other things change, he changes not. The transformations
> of things are to him the developments prescribed for them, and he
> keeps fast hold of the author of them.'
> -translated by James Legge in the *Sacred Books of The East*.
> Source:郭慶藩《莊子集釋》.北京: 中華書局, 1985, p.189.

(34). "攬" is "覽", see 中央研究院《搜詞尋字》.

(35). "嘗" is "嚐", please see *Kangxi Dictionary* (《康熙字典》)"嘗".

(36). "臨文" here refers to "撰寫或研讀、抄錄文辭(author, study, or transcribe texts)" as seen in 劉勰《文心雕龍•練字》：

> 諷誦則績在宮商，<u>臨文</u>則能歸字形矣。
> Source: 劉勰《文心雕龍》卷八練字. 上海: 商務印書館，1937，p.54.

(37). "喻" here means "開導(ease one's mind)", see 中央研究院《搜詞尋字》.

Wang here was asserting that he understood and shared the same sentiments of frustration with the people of the past. Such an interpretation is consistent with Lines 29 and 35.

(38,39). "齊彭殤" alludes to Zhuangzi's (莊子) assertion in *Discussion on Making All Things Equal* (《齊物論》) that living long and living short is one and the same:

天下莫大於秋豪之末，而大山為小；莫壽乎殤子，而彭祖為夭。天地
與我並生，而萬物與我為一。

There is nothing in the world bigger than the tip of a fine hair, and a
huge mountain is actually tiny. No one has lived longer than a person
who died at birth (殤子), and Peng Zu (彭祖, a legendary person who
was known to have lived a very long life) died young. Heaven and
earth were born at the same time I was, and so all things are one with
me.
-translated by Burton Watson in *The Complete Works of Zhuangzi*,
with revisions by KS Vincent Poon.
Source:郭慶藩《莊子集釋》.北京: 中華書局, 1985, p.79.

(40). "所以" is "原故(what is behind)" while "興懷" means "引起感
觸(stir emotions)".

(41). "致" here means "致使/導致(cause/origin)" not necessarily "
情趣(sentiments)". Wang was arguing that the origin of stirring
one's emotions (particularly frustration and sadness) is one and
the same throughout the ages, and so future readers should
resonate with his writing here (Line 36). Such interpretation is
strongly supported by Lines 28 to 30 and 33.

Modelling of *Lanting Xu*
by KS Vincent Poon

永和九年歲在癸丑暮春之初會
于會稽山陰之蘭亭脩禊事
也群賢畢至少長咸集此地
有崇山峻領茂林脩竹又有清流激
湍暎帶左右引以為流觴曲水
列坐其次雖無絲竹管絃之
盛一觴一詠亦足以暢敘幽情
是日也天朗氣清惠風和暢仰
觀宇宙之大俯察品類之盛
所以遊目騁懷足以極視聽之
娛信可樂也夫人之相與俯仰
一世或取諸懷抱悟言一室之內
或因寄所託放浪形骸之外雖
趣舍萬殊靜躁不同當其欣
於所遇暫得於己快然自足不

知老之將至及其所之既惓
情隨事遷感慨係之矣向之
所欣俛仰之間以為陳迹猶不
能不以之興懷況修短隨化終
期於盡古人云死生亦大矣豈
不痛哉每攬昔人興感之由
若合一契未嘗不臨文嗟悼不
能喻之於懷固知一死生為虛
誕齊彭殤為妄作後之視今
亦由今之視昔悲夫故列
敘時人錄其所述雖世殊事
異所以興懷其致一也後之攬
者亦將有感於斯文

CHAPTER THREE:

Elaborations on the Biography of Ni Kuan

兒寬贊帖

KS Vincent Poon's model of Wang Xizhi's (王羲之)

Ling Jiu Tie (靈柩帖), *Ci Yan You Yì Tie* (慈顏幽翳帖), and *Yua Huan Tie* (遠宦帖)

Chapter Three:

Elaborations on the Biography of Ni Kuan (兒寬贊帖)

Historical Background

(I)

Chu Suiliang's (褚遂良, 596-658AD) *Elaborations on the Biography of Ni Kuan* is considered to be one of the finest standard script works in Chinese history. The piece is renowned for its elegance as well as its dynamic variations of thickness within each brushstroke. The original was long lost but a model of it can be observed in the National Palace Museum, Taipei, Taiwan. This model might not have been scribed according to Chu Suiliang's original and was presumably written by an unknown calligrapher after Tang but before Song Dynasty, which was the Five Dynasties and Ten Kingdoms period (907–979AD).[1] Further, "韋玄成" was incorrectly scribed as "韋弘成" in the 37th column starting from the right.

(II)

The textual content of this artwork was extracted from the *Book of Han* (《 漢書 》), which was compiled by Ban Gu (班固, 32–92AD). Similar to Sima Qian's elaborations (太史公曰) in *Records of the Grand Historian* (《 史記 》), the words seen in this artwork were Ban Gu's personal elaboration at the very end of *Biographies of Gongsun Hong, Bu Shi and Ni Kuan* (公孫弘卜式兒寬傳) in Volume 58 of the *Book of Han* (《 漢書 》 卷五十八); they illustrated and compared imperial court personnel between the administrations of Han Emperors Wu (武帝) and Xuan (宣帝). Accordingly, it is wrong for those who interpret it as a eulogy since "贊" here should be interpreted as "說明(to elaborate)" not "

稱頌(to praise/to eulogize)"[2].

(III)

Chu Suiliang was the son of Tang Dynasty scholar and officer Chu Liang (褚亮, 560-647AD) and was renowned for his "broad and extensive understanding of literature and history (博涉文史)" as well as his "adeptness in scribing the standard script (尤工隸書)".[3] Wei Zheng (魏徵, 580-643 AD) once remarked Chu Suiliang's calligraphy was "vigorous and powerful, very much bearing the form of Wang Xizhi's calligraphy (下筆遒勁，甚得王逸少體)".[4] Tang Emperor Taizong (唐太宗, 598-649 AD) recognized Chu's talents, appointed him to high office as a close adviser, and relied heavily on his many recommendations.[5] During Taizong's final moments, Taizong valued deeply Chu's steadfast loyalty (忠烈) and so entrusted Chu to assist his son and successor, Emperor Gaozong (唐高宗, 628-683AD), in governing the country.[6]

Chu Suiliang's later years was rather turbulent and bitter, however. His staunch and unwavering objection against Emperor Gaozong's designation of Concubine Wu (昭儀武氏) as the Queen (Concubine Wu later became Empress Wu Zetian 武則天 who overthrew Tang to become the first and only Empress in Chinese history) ultimately led him to be demoted and ousted from the imperial court.[7] He died shortly thereafter at the age of 63.

(IV)

Chu Suiliang's elegant, honest and compelling style of calligraphy was certainly attributed to his noble, righteous, and unwavering temperament. This is what Sun Guoting (孫過庭) in his renowned *A Narrative on Calligraphy* (書譜) described calligraphy as "the culmination of the principles of righteousness, and so those who are wise, talented and virtuous should be able to write good cal-

ligraphy as well (固義理之會歸，信賢達之兼善者矣)"[8] and a "testament of living through the fickleness of the mundane world while maintaining one's noble integrity unaltered throughout the times (驗燥濕之殊節，千古依然)"[9]. Chu Suiliang's calligraphy is certainly one of the very best examples to demonstrate this philosophy in the history of Chinese calligraphy. Another is Yan Zhenqing's (颜真卿, see *Chapter IV: A Poem on General Pei*).

Translation

1. 漢興六十餘載，海內艾安，府庫充實。
The Han Dynasty had been established with much prosperity for over sixty years; pervasive calm and peace (艾安)[10] was observed under the administration throughout the land and the treasury was ample and sufficient.

2. 而四夷未賓，制度多闕。
Yet, surrounding barbarous tribes from all directions (四夷)[11] remained defiant to Han's rule, and her various institutions had many deficiencies.

3. 上方欲用文武，求之如弗及。
The Emperor (Emperor Wu of Han, 漢武帝, 157BC-87BC) desired to apply talents of Wen and Wu (文武)[12] in governing and couldn't wait to seek them as if it were too late to do so (求之如弗及)[13].

4. 始以蒲輪迎枚生，見主父而歎息。
He first sent a luxurious horse carriage to invite scholar (生) Mei Cheng (枚乘, ?-140BC) and lamented he did not meet Zhufu Yan (主父偃, ?-126BC) sooner.

5. 羣士慕嚮，異人並出。
Many wise men then admired and approached the Emperor and extraordinary individuals emerged from all over the land.

6. 卜式拔於芻牧，弘羊擢於賈豎；
Bu Shi (卜式, ?-?BC) came forth (拔) from being an adept shepherd (芻牧), while Sang Hongyang (桑弘羊, 155-80BC) rose (擢) from being a petty merchant (賈豎)[14];

7. 衛青奮舊於奴僕，日磾出於降虜；
Wei Qing (衛青, ?-106BC) ascended (奮舊)[15] from being a slave servant, while Jin Midi (金日磾, 134-86BC) emerged from being a
66

prisoner of war;

8. 斯亦曩時版築飯牛之明(朋?)已。
they all once (曩時)[16] belonged merely to the likes (朋)[17] of lowly workers and peasants (版築飯牛)[18].

9. 漢之得人，於茲為盛。
Considering the talented individuals that Han had acquired over her history, this (茲) was the time when talents were extremely abundant and bountiful.

10. 儒雅則公孫弘、董仲舒、兒寬;
The ones who bore exemplary Confucian demeanors were Gongsun Hong (公孫弘, 200 – 121BC), Dong Zhongshu (董仲舒, 179-104BC) and Ni Kuan (兒寬, ?-103BC);

11. 篤行則石建、石慶; 質直則汲黯、卜式;
the ones who acted in earnest and perseverance (篤行) were Shi Jian (石建, ?-123BC) and Shi Qing (石慶, ?-103BC), while the most honest and candid were Ji An (汲黯, ?-112BC) and Bu Shi (卜式);

12. 推賢則韓安國、鄭當時;
excelling in discovering and recommending talented individuals to the Emperor were Han Anguo (韓安國, ?-127BC) and Zheng Dangshi (鄭當時, ?-?BC);

13. 定令則趙禹、張湯;
the masters in crafting policies and lawmaking (定令) were Zhao Yu (趙禹, ?-100BC) and Zhang Tang (張湯, ?-116BC);

14. 文章則司馬遷、相如;
the proficient writers were Sima Qian (司馬遷, 145-86BC) and Sima Xiangru (司馬相如, 179-117BC);

15. 滑稽則東方朔、枚皐;
the skilled debaters (滑稽)[19] were Dongfang Shuo (東方朔, 154-93BC) and Mei Gao (枚皐, 153-?BC, Son of Mei Cheng 枚乘);

16. 應對則嚴助、朱買臣;
the ones who were adept in countering were Yan Zhu (嚴助, ?-122BC) and Zhu Maichen (朱買臣, ?-115BC);

17. 歷數則唐都、洛下閎;
the experts in calendars and astronomy (歷數)[20] were Tong Du (唐都, ?-?BC) and Luo Xiahong (洛下閎, 156-87BC) ;

18. 協律則李延年 ，運籌則桑弘羊;
the virtuoso in music was Li Yannian (李延年, ?-90BC), while the savvy administrator was Sang Hongyang (桑弘羊);

19. 奉使則張騫、蘇武;
the accomplished diplomats were Zhang Qian (張騫, 164-114BC) and Su Wu (蘇武, 140-60BC);

20. 將率則衛青、霍去病;
the mighty generals leading the army were Wei Qing (衛青, ?-106BC) and Huo Qubing (霍去病, 140-117BC);

21. 受遺則霍光、金日磾。其餘不可勝紀。
the venerable assistants to the heir were Huo Guang (霍光, ?-68BC) and Jin Midi (金日磾, 134-86BC). There were also numerous others, so many that it is impossible to list them all here.

22. 是以興造功業，制度遺文，後世莫及。
Hence, the number of glorious achievements accomplished (興造功業) as well as the amount of laws and institutions established (制度遺文) within that period could not be matched nor surpassed by any other later era.

23. 孝宣承統，纂修洪業，亦講論六藝。

When Emperor Xuan of Han (漢宣帝, 91-48BC) succeeded the throne, the Emperor refined himself to inherit the entire Great Enterprise (纂修洪業)[21] and continued to dissertate (講論) on the Confucian Six Arts (六藝)[22] in ruling the empire.

24. 招選茂異，而蕭望之、梁丘賀、夏侯勝、韋弘(玄)成、嚴彭祖、尹更始以儒術進;

The administration continued to recruit unique and exceptional (茂異) individuals including Xiao Wangzhi (蕭望之, ?-46BC), Liangqiu He (梁丘賀, ?-?BC), Xiahou Sheng (夏侯勝, ?-?BC), Wei Xuancheng (韋玄成, ?-36BC), Yan Pengzu (嚴彭祖, ?-?BC) and Yin Gengshi (尹更始, ?-?BC), all of whom advanced (進) to their official posts for their Confucian (儒) thoughts and contentions (術)[23];

25. 劉向、王褒以文章顯;

Liu Xiang (劉向, 77-6BC) and Wang Bao (王褒, 90-51BC) stood out for their elegant writings;

26. 將相則張安世、趙充國、魏相、丙吉、于定國、杜延年;

there were great generals and ministers including Chang Anshih (張安世, ?-62BC), Zhao Chongguo (趙充國, 137-52BC), Wei Xiang (魏相, ?-59BC), Bing Ji (丙吉, ?-55BC), Yu Dingguo (于定國, ?-40BC), and Du Yannian (杜延年, ?-52BC);

27. 治民則黃霸、王成、龔遂、鄭弘、召信臣、韓延壽、尹翁歸、趙廣漢、嚴延年、張敞之屬;

those who were adept at managing civil affairs were Huang Ba (黃霸, 130-51BC), Wang Cheng (王成, ?-?BC), Gong Sui (龔遂, ?-?BC), Zheng Hong (鄭弘, ?-?BC), Shao Xinchen (召信臣, ?-?BC), Han Yanshou (韓延壽, ?-57BC), Yin Wenggui (尹翁歸,?-62BC), Zhao Guanghan (趙廣漢, ?-65BC), Yan Yannian (嚴延年, ?-58BC), Zhang Chang (張敞, ?-?BC) and the likes;

28. 皆有功迹見述於世。

all of them had attained extraordinary achievements that were well known and described throughout the ages.

29. 參其名臣，亦其次也。

Studying (參)[24] these brilliant and renowned officials closely, however, they are slightly inferior to those under Emperor Wu's reign.

Footnotes

(1). The model in Taipei's National Palace Museum contains characters "世" and "民", which were taboo characters (避諱) during Chu Suiliang's times of the Tang Dynasty. Hence, it cannot be the original work by Chu Suiliang himself nor a model that was scribed during the Tang Dynasty.

Further, this particular model has the character "弘" intentionally scratched out throughout the work. "弘" was a taboo character from the very beginning of Song Dynasty as Zhao Hongyin (趙弘殷) was the father of the founding Song Emperor Zhao Kuangyin (趙匡胤), see 張丑《清河書畫舫》卷三下. 欽定四庫全書子部清河書畫舫, 乾隆五十二年版, p.24. Hence, it can be concluded that the model cannot be made during the Song Dynasty.

Taken together, from the perspective of assuming the strict prohibition of using taboo characters in ancient China, the work must thus be made after Tang Dynasty but before Song Dynasty. This strongly suggests that the work was hence born during the Five Dynasties and Ten Kingdoms period (907-979AD).

(2). "贊" here should be interpreted as "說明(to elaborate)" and "令微者得著(to annotate an inconspicuous point)", please see *Kangxi Dictionary* (《康熙字典》)"贊".

(3) 劉昫,《舊唐書》卷八十褚遂良傳。臺灣: 臺灣中華書局, 1971, 冊六 p. 1。

"隸書" here refers to "楷書 (standard script)" which was known as "今隸(current clerical script)" in Tang dynasty.

(4). Ibid.

(5). Ibid, pp.1,2,6.

(6). Ibid, p.6.

(7). Ibid, p.6.

(8). KS Vincent Poon & Kwok Kin Poon, *A Narrative on Calligraphy by Sun Guoting* 英譯書譜. Toronto: The SenSeis, 2018, p.19, Line 67.

(9). Ibid, p.25, Line 102.

(10). "艾" here means "治理；安定(calm/stable under rule)", see 中央研究院《搜詞尋字》.

(11). "四夷" specifically refers to "東夷 (The Eastern Yi)", "南蠻 (The Southern Man)", "西戎(Western Rong)", and "北狄(Northern Di)", the four nomadic tribes outside the borders of Han China.

(12). 文 (Wen) here refers to individuals who are adept in civil duties while 武 (Wu) refers to individuals who are skilled in militaristic duties.

(13). "弗及" means "來不及(can't wait/as if it is too late)".

(14). "賈竪" was a term used to described merchants, who were generally regarded as the most inferior among the four social classes in ancient China. In ancient China, "士 (gentry/intellect)" was considered as the top social class followed by "農 (farmers)" then "工 (workers)" and finally "商 (merchants)".

(15). In *Biographies of Gongsun Hong, Bu Shi and Ni Kuan* (公孫弘卜式兒寬傳) in the *Book of Han* (《漢書》), the character "舊" is absent in this sentence. See 班固《漢書》卷五十八公孫弘卜式兒寬傳. 香港:中華書局, 1970, p.2633.

(16). "曩時" means "往時/以前(once upon/in the past)" as in 賈誼《過秦論上》：

深謀遠慮，行軍用兵之道，非及曩時之士也。

As for the meticulous and deep deliberations as well as the way to command the army and strategizing the troops, we cannot match the officers of the past.

(interpreted by KS Vincent Poon)

Source: 賈誼 《新書》卷一過秦論上. 鴻文書局, 光緒十九年版, p.2.

(17). In the *Book of Han* (《漢書》), the character "明" is "朋". See 班固 《漢書》 卷五十八公孫弘卜式兒寬傳. 香港:中華書局, 1970, p.2633.

(18). "版築飯牛" can be broken down into "those who build walls" (版築) and "those who feed cows" (飯牛). Collectively, the entire term is used to describe laborers and peasants of humble backgrounds.

(19). "滑稽" In classical literature refers to "能言善辯(adept in debating)" as in Sima Qian's *Records of the Grand Historian - The Biographies of Wits and Humorists* 《史記•滑稽列傳》:

淳于髠者，齊之贅婿也。長不滿七尺，滑稽多辯。

Source: 司馬遷 《史記》卷一百二十六滑稽列傳. 香港: 廣智書局, 出版年份缺, 冊六 p.1.

(20). "歷" here is "曆", please see *Kangxi Dictionary* (《康熙字典》)"歷".

(21). "纂修洪業" was derived from the classical text *Guo Yu* (《國語》):

及景子長于公宮，未及教訓而嗣立矣，亦能纂修其身以受先業，無謗于國。

As for your father Zhao Jingzi (景子) who grew up in the palace, although he did not yet have the chance to be taught by the imperial mentors when he succeeded the throne, he was able to refine his temperament to inherit the enterprise left by his predecessors, and so no one in the country said anything to belittle him.

(interpreted by KS Vincent Poon)
Source: 《國語》卷十五晉語九. 欽定四庫全書薈要史部國語, 乾隆四十二年版, pp.6-7.

"洪業(Great Enterprise)" refers to the enterprise of the entire Han Empire.

(22). "蓺" is "藝", please see *Kangxi Dictionary* (《康熙字典》) "蓺".

(23). "術" here means "學說；主張 (school of thought/contention)", see 中央研究院 《搜詞尋字》.

(24). "參" means "研究；商討(to study/deliberate)", see 中央研究院 《搜詞尋字》.

Modelling of *Elaborations on the Biography of Ni Kuan* by KS Vincent Poon

漢 興 六 十 餘 載 海

內 文 安 府 庫 充 實

而 四 裔 未 賓 制 度

多 闕 上 方 欲 用 文

武 ヾ ヽ 如 邪 及 怡

以 蒲 輪 迎 枚 生 見

主 父 而 歎 息 群 士

慕 嚮 異 人 並 出 卜

式 拔 於 芻 牧 弘 羊

擢 於 賈 豎 衛 青 奮

於 奴 僕 日 磾 出

於 降 虜 斯 亦 曩 時

版 築 飯 牛 之 明 已

漢 之 得 人 於 茲 為

盛 儒 雅 則 公 孫 弘

董仲舒兒寬篤行則石建石慶質直則汲黯卜式推賢則韓安國鄭當時定令則趙禹張湯文章則司馬遷相如滑稽則東方朔枚皋應對則嚴助朱買臣曆數則唐都洛下閎協律則李延年運籌則桑弘羊奉使則張騫蘇武將率則衛青霍去病受遺則霍光金日磾其餘不

可勝紀是以興造
功業制度遺文後
世莫及孝宣承統
纂修洪業亦講論
六蓺招選茂異而
蕭望之梁丘賀夏
侯勝韋玄成嚴彭
祖尹更始以儒術
進劉向王襃以文
章顯將相則張安
世趙充國魏相丙
吉于定國杜延年
治民則黃霸王成
龔遂鄭弘召信臣
韓延壽尹翁歸趙

漢藝筆張詠之
屬皆有功述見述
於世察其名臣心
其次也

臣褚遂良書

右褚遂良書兒
寬積二千十六
年春滿君河臨

CHAPTER FOUR:

A Poem on General Pei

裴將軍帖

奄至此禍情顛不遂缅
始欲緒痛之深至情
不能至悲汝當可臻佳
㐱不盡汩無由敘哀悲
酸

日月如馳煥奄首再
周忌月號松大祥奉
瞻廓然如摧與摧情
如切割汩之摧慕省
法㐱戚
㝢華之奄至以日月如
馳悵戕戕沖其尚計

KS Vincent Poon's model of Wang Xizhi's (王羲之)
Yan Zhi Tie (奄至帖) and *Ri Yue Ru Chi Tie* (日月如馳帖)

Chapter Four:

A Poem on General Pei (裴將軍帖)

Historical Background

(I)

A Poem on General Pei (裴將軍帖) is one of the many outstanding works written by the renowned Tang Dynasty minister and calligrapher Yan Zhenqing (顏真卿, AD 709-785)[1]. The highlight of this masterpiece is the different script styles written within one single calligraphic work, a practice that is rarely employed in traditional Chinese calligraphy where a work is usually written in one particular script style. Standard script, semi-cursive script, along with cursive script are all compellingly, coherently, and harmoniously displayed at the same time with a touch of clerical script flavor seen in some of the brushstrokes. Indeed, this extraordinary work is regarded as "odd, strange and unprecedented (怪怪奇奇, 前無古人)"[2], "bold and open, singularly pioneering a completely new horizon (縱橫豪宕，獨闢異境)"[3], and can "startle one's mind and shake one's spirit (驚心動魄)"[4]. Unsurprisingly, it is considered by some as the best calligraphic wonder crafted by Yan Zhenqing (魯公第一奇跡).[5] The original work can no longer be found; the best representation of the work is an ink-rubbed copy from a stone inscription of the original.

(II)

The work's vigor, liveliness, as well as its magnificent powerful brushstrokes (筆力雄偉)[6] are consistent with Yan Zhenqing's honest, principled, unyielding, and strong-willed personality. According to *Old Book of Tang* (《舊唐書》), Yan led the army against the rebellious An Lushan (安祿山, 703-757AD), frequently gave candid and forthright admonitions to the Emperor despite offending many higher government officials, and never betrayed

Tang even being threatened and eventually executed by Li Xilie (李希烈, ?-786AD).[7] Thus, he was regarded by Tang Emperor Dezong (唐德宗) as talented, outstanding, faithful and having an unbending will ("器質天資,公忠傑出", "堅貞一志").[8]

<div align="center">(III)</div>

Yan Zhenqing's calligraphy is often modelled and studied by many today. While it is certainly important to mimic and learn the exterior physical forms of Yan's script, most have forgotten to emulate Yan's noble temperament in achieving a higher level in the art of calligraphy; indeed, "to not pursue learning the fundamental qualities but only to model the exterior superficial qualities cannot be regarded as a good learner (不求其本, 而但傲其面目,亦未為善學者也)"[9]. Truly, the art of Chinese calligraphy is fundamentally "a testament to one's moral character (驗燥濕之殊節)"[10], and so "the essence and ingenuity of *shudao/shodo* (書道) is temperament, while being capable to scribe well the exterior physical forms comes second (書道妙在性情，能在形質)"[11]. Hence, learning calligraphy without cultivating one's temperament shall certainly limit one's calligraphic achievement.

<div align="center">(IV)</div>

Yan's *A Poem on General Pei* was written in dedication to Tang Dynasty's famed general Pei Min (裴旻, ?-?AD), who was renowned for his swordsmanship, might, audacity, and valor in defending the country against the nomadic Xi (奚).[12] Pei Min's swordplay, Li Bai's (李白, 701-762AD) poems, and Zhang Xu's (張旭, 675-750AD) cursive script were decreed together by Emperor Wenzong (唐文宗, 809-840AD) as the "Three Ultimates of Tang Dynasty (唐代三絕)".[13]

Translation

1. 裴將軍！
General Pei!

2. 大君制六合，猛將清九垓。
While the glorious Emperor commanded all under the Heavens (六合), your fierce troops brought peace (清) to the entire country (九垓).

3. 戰馬若龍虎，騰陵何壯哉！
Your war horses were as striking as flying dragons and fierce tigers; they all moved fiercely with great speeds (騰陵)[14], how magnificent they were!

4. 將軍臨北荒，怛赫耀英材。
As you approached the Northern Frontiers, you revealed your dazzling brilliance and awe (怛)[15] everyone around you.

5. 劍舞躍游雷，隨風縈且迴。
Your sword danced in rhythm, leaped liked the galloping thunder, and drifted with the circulating winds.

6. 登高望天山，白雪正崔嵬。
You climbed and observed the Mountains of Heaven (天山), the tall and lofty peaks (崔嵬)[16] of which were all, at that time, covered with white snow.

7. 入陣破驕虜，威聲雄震雷。
As you pummelled into the enemy's battle formation to decimate the conceited barbarians, your mighty presence roared like the rolling thunder.

8. 一射百馬倒，再射萬夫開。
As you fired a single shot from your bow, hundreds of war horses fell; as you fired again, thousands of enemies dispersed(開)[17].

9. 匈奴不敢敵，相呼歸去來。

The Xiongnu (匈奴)[18] feared your presence, they all exclaimed to each other in retreat.

10. 功成報天子，可以畫麟臺。

You proudly returned and proclaimed your triumphant success to the Emperor, and you certainly could be portrayed in the Qilin Pavilion (可以畫麟臺)[19].

Footnotes

(1). 顏真卿,《贈裴將軍》。《全唐詩》 卷一百五十二。欽定四庫全書薈要集部全唐詩, 康熙四十六年版, p.13。黃本驥編,《顏魯公全集》。 上海: 上海仿古書店, 出版年份缺, p.238。

(2). 黃本驥編,《顏魯公全集》。仝上, p.239。

(3). 劉正成 ,《中國書法鑒賞大辭典》。北京：大地出版社 , 1989, p.554。

(4). See (2).

(5). Ibid.

(6). Ibid.

(7). 劉昫,《舊唐書》 卷一百二十八顏真卿傳。臺灣: 臺灣中華書局, 1971, 冊七 pp. 5-9。

(8). Ibid, p.9.

(9). See (2).

(10). KS Vincent Poon & Kwok Kin Poon, *A Narrative on Calligraphy by Sun Guoting* 英譯書譜. Toronto: The SenSeis, 2018, p.25, Line102, "驗燥濕之殊節 , 千古依然".

(11). See 包世臣《藝舟雙楫》答三子問. 《歷代書法論文選》.上海: 上海書畫出版社, 1979, p.667.

(12). 歐陽修,《新唐書》卷二百二李白傳 。北京: 中華書局, 1975, p. 5764。

(13) Ibid.

(14). The character "陵" here refers to "馳(moving fiercely with great speed)", see *Kangxi Dictionary* (《康熙字典》)"陵".

(15). "怛" here is "憚", see *Kangxi Dictionary* (《康熙字典》)"怛". Hence, "怛赫" is "憚赫" which means "威震 (dazzle and awe)". Note 《全唐詩》as well as 《顏魯公文集》 both recorded "怛" as "烜" due probably to transcribing error.

(16). "崔嵬" here refers to "lofty and tall objects, usually referring to high mountains (形容高峻，高大雄偉的物體, 多指山)", see 《漢典》.

(17). "開" in this context means "散/裂(dispersed/split up)" as in 杜甫《梅雨》：

　　茅茨疏易濕，雲霧密難開。
　　Source: 《全唐詩》卷二百二十六. 欽定四庫全書薈要集部全唐詩, 康熙四十六年版, p.2.

(18). Here, "Xiongnu (匈奴)" refers to the nomadic tribe of Xi (奚). Historically, "匈奴" generally refers to nomadic tribes beyond the borders of Northern and Western China. For instance, Song Dynasty's Yue Fei (岳飛) wrote "壯志飢餐胡虜肉，笑談渴飲匈奴血" in his renowned poem 《滿江紅》.

(19). "麟臺" is "麒麟閣(Qilin Pavilion)" as suggested in the following Tang Dynasty's poems:

　　A. 李白 《塞下曲六首》：
　　陣解星芒盡，營空海霧消。功成畫麟閣，獨有霍嫖姚(霍去病)。
　　Source: 《全唐詩》卷一百六十四．欽定四庫全書薈要集部全唐詩, 康熙四十六年版, p.4.

　　B. 高適 《塞下曲》：
　　萬里不惜死，一朝得成功。畫圖麒麟閣，入朝明光宮。
　　Source: 《全唐詩》卷二百一十一．欽定四庫全書薈要集部全唐詩, 康熙四十六年版, p.2.

"麒麟閣(Qilin Pavilion)" was originally established in the Han Dynasty to commemorate "The Eleven Outstanding and Meritorious Officials (十一功臣)", which included Huo Guang (霍光, ?-68BC), Zhang Anshi (張安世, ?-62BC), Han Zeng (韓增, ?-56BC), Zhao Chongguo (趙充國, 137-52BC), Wei Xiang (魏相, ?-59BC), Bing Ji (丙吉, ?-55BC), Du Yannian (杜延年, ?-52BC), Liu De (劉德, ?-57BC), Liang Qihe (梁丘賀, ?-?BC), Xiao Wang-zhi (蕭望之, ?-46BC), and Su Wu (蘇武, 140-60BC). It was Han Emperor Xuan (漢宣帝, 91-48BC) who decreed the portraits of each of these heroes to be drawn on the walls of the Pavilion, and so collectively these heroes were known as "The Eleven Outstanding and Meritorious Officials of the Qilin Pavilion(麒麟閣十一功臣)".

"可以畫麟臺" was written here to contend Pei Man's might and accomplishments were comparable to those of the eleven heroes of the Han outlined above.

Modelling of *A Poem on General Pei*
by KS Vincent Poon

CHAPTER FIVE:

Huai Su's Autobiography

懷素自叙帖

KS Vincent Poon's model of Huai Su's (懷素) *Guo Zhong Tie* (過鍾帖)

Chapter Five:

Huai Su's Autobiography (懷素自叙帖)

Historical Background

(I)

Huai Su's Autobiography (懷素自叙帖) was scribed in 776AD[1] by a Buddhist monk named Huai Su (懷素, 725-785AD or 737-799AD) and is considered to be one of the best cursive script (草書) works in Chinese history. There are very few, if any, formal official historical records (正史) on the life of Huai Su; an earlier unofficial documentation on him is *Supplement to the History of the Tang dynasty* (《唐國史補》) by Tang Dynasty's Li Siu (李肇, ?-?AD):

> 長沙僧懷素，好草書，自言得「草聖三昧」。棄筆堆積，埋於山下，號曰「筆塚」。[2]
>
> Monk Huai Su of Changsa adored the cursive script and self-pro-claimed he thoroughly grasped the true essence of the "Sage of the Cursive Script (Zhang Zhi, 張芝, ?-192 AD)" in scribing calligraphy. He discarded and buried many of his used brushes at the foot of a mountain which was called "The Tomb for the Brushes". (interpreted by KS Vincent Poon)

Other descriptions of Huai Su can mostly be found in Tang Dy-nasty Lu Yu's (陸羽, 733-804AD) essay *The Biography of Monk Huai Su of the Tang* (《唐僧懷素傳》)[3] and poems by other renowned poets[4]. From these writings, Huai Su was known for his elegant and wild cursive script in his times; his calligraphic accomplishments were considered to be on par with another venerable cursive script master Zhang Xu (張旭, 675-750 AD), who is often mistakenly identified by many today to be the "草聖

(Sage of the Cursive Script)"[5]. Furthermore, his discourse with the venerable Yan Zhenqing (顏真卿, 709-785 AD) contributed significantly to the evolution of the art of the cursive script and later inspired Song Dynasty's uniquely wild cursive styles.[6]

(II)

The original *Autobiography* was long lost, but there once existed three different modelling copies (臨摹本) of the original *Autobiography*. According to literature written by Zeng Yu (曾紆) in 1132AD during the Southern Song Dynasty (南宋紹興二年), these were the Shu version (藏在蜀中石陽休家), the Fung version (藏在馮當世家), and the Su version (藏在蘇子美家).[7] The Su version currently resides at the National Palace Museum, Taipei, Taiwan, and is recently determined to be a trace-modelling copy (映寫) of the original made during the Northern Song Dynasty (北宋, 960–1126 AD)[8]. Note further this Su version at the National Palace Museum is not the perfect original modelling replica as, at the minimum, its first six rows from the right have been confirmed to be "repairs" (六行後補) written by another calligrapher at a later era.[9]

(III)

The model presented at the end of this chapter was scribed according to the Shu version (蜀本) of the *Autobiography*. Compared to the Su version, the Shu version is more aesthetically pleasing as it presents more variabilities and dynamics within and among different characters. Further, the Shu version is more consistent with Huai Su's unique artistic approach to the cursive script.[10] Hence, it can be said that the Shu version is of a higher caliber than the Su version in terms of artistic accomplishment.

A portion of the Shu version of *Huai Su's Autobiography*
(蜀本懷素自叙帖)

(IV)

Huai Su's distinct and exquisite cursive script can be traced back to Han Dynasty's renowned calligraphers Du Du (杜度, ?-? AD) and Cui Yuan(崔瑗, 77-142 AD). The conveyance of the traditional art of the cursive script was chronicled in Yan Zhenqing's *Preamble of A Collection of Poems Dedicated to Master Huai Su's Cursive Script* (懷素上人草書歌序), which was incorporated into *Huai Su's Autobiography* (see V below). In this *Preamble*, Yan Zhenqing narrated that the wonders of the cursive script were first showcased by the renowned Han Dynasty calligraphers Du Du (杜度) and Cui Yuan (崔瑗), who were succeeded by Zhang Zhi (張芝, ?-192 AD), followed by Wang Xizhi (王羲之, 303-361 AD) and Wang Xianzhi (王獻之, 344-386 AD) of the Eastern Jin Dynasty, subsequently passed on to Yu Shinan (虞世南, 558-638 AD) as well as Lu Jianzhi (陸柬之, 585-638 AD) and Lu Yanyuan (陸彥遠, ?-?AD), and finally reached Zhang Xu (張旭, 675-750 AD) who taught Yan Zhenqing as well as Wu Tong (鄔彤, ?-? AD), Huai Su's calligraphy teacher. Adding their per-

sonal relationships together, one can conclude the conveyance of the cursive script from Du Du to Huai Su is as follows:

Du Du (杜度, ?-? AD)

↓

Han Dynasty (206BC-220AD)

Cui Yuan(崔瑗, 77-142 AD)

↓

Zhang Zhi (張芝, ?-192 AD)
"草聖,Sage of the Cursive Script"

Legend

→ Directly instructed

⇢ Indirectly instructed or had an impact on (via modelling or mimicking the style of the predecessor)

↓

Jin Dynasty (265-420AD)

Wang Xizhi (王羲之, 303-361 AD)

↓

Wang Xianzhi (王獻之, 344-386 AD), son of Wang Xizhi

Master Zhiyong (智永- 王法極,?-?AD), a seventh-generation descendant of Wang Xizhi. Lived during the Sui Dynasty (581-618AD)

Yu Shinan (虞世南, 558-638 AD), uncle of Lu Jianzhi

↓

Tang Dynasty (618-907AD)

Lu Jianzhi (陸柬之, 585-638 AD), nephew of Yu Shinan and grandfather of Zhang Xu

↓

Lu Yanyuan (陸彥遠, ?-?AD). son of Lu Jianzhi and uncle of Zhang Xu

↓

Zhang Xu (張旭, 675-750 AD) grandson of Lu Jianzhi and nephew of Lu Yanyuan

↓ ↓

Wu Tong (鄔彤, ?-?AD) Yan Zhenqing (顏真卿, 709-785 AD) a student of Zhang Xu a student of Zhang Xu

↓

Huai Su (懷素, 725-785 AD or 737-799 AD)

(V)

The magnificent *Autobiography* can be divided into four main parts:

Lines 1 to 11: A very short self-introduction by Huai Su outlining the whereabouts of his own hometown, his becoming of a Buddhist monk at an early age, and his passion for Chinese calligraphy.

Lines 12 to 35: A description of Huai Su's calligraphic accomplishments as documented in Yan Zhenqing's *"Preamble of A Collection of Poems Dedicated to Master Huai Su's Cursive Script"* (懷素上人草書歌序) [11], which included a brief description on the origin and conveyance of the wonders of the cursive script in the eyes of Yan Zhenqing.

Lines 36 to 50: Selected praises of Huai Su from various notaries, including those written by Dai Shulun (戴叔倫, 732-789 AD), Wang Yong (王邕, ?-? AD) and Xu Yao (許瑤, ?-? AD). These praises commented mainly on the physical forms (形似), formats and structures (機格) of Huai Su's calligraphy as well as the pace (疾速) in which it was scribed.

Lines 51-53: A concluding paragraph wherein Huai Su humbly asserted that he was not qualified for such praises along with the date and Huai Su's signature at the very end.

Translation

1. 懷素家長沙。幼而事佛。
Huai Su's home was in Changsha. Ever since I was very young, I had been studying and serving Buddhism.

2. 經禪之暇, 頗好筆翰。
Between meditations and studying the scriptures, I liked to practise the art of calligraphy during my leisure time.

3. 然恨未能遠覩前人之奇迹,
Unfortunately, I regretted not to have the chance to glance at the marvelous masterpieces scribed by the many great masters of the past,

4. 所見甚淺。
and so my scope of the art of calligraphy was very limited.

5. 遂擔笈杖錫, 西遊上國。
Accordingly, I decided to take my bookcase and my Khakkhara staff (杖錫)[12] with me and travelled west to the capital of the country (上國)[13].

6. 謁見當代名公,
I visited as well as learned from many renowned scholars and statesmen of the times there,

7. 錯綜其事。
and took reference to their many resources (錯綜)[14] in the matter of learning calligraphy (其事).

8. 遺編絕簡, 往往遇之。
As such, rare texts and invaluable books, I frequently encountered them.

9. 豁然心胸，略無疑滯。
My mind was then opened as well as enlightened, and I felt liberated without any burden.

10. 牋絹素，多所塵點，
Pieces of exquisite papers and plain silks (牋絹素)[15] were marred by my many ink blots,

11. 士大夫不以為怪焉。
but the statesmen never found me odd and bizarre.

12. 顏刑部書家者流，精極筆法，水鏡之辨，
Minister of Justice Yan (顏真卿, Yan Zhenqing), who was in the league (流)[16] of great calligraphers (書家) and had exceptional penmanship skills as well as broad knowledge and sound judgment,

13. 許在末行。
approved (許) my art by recognizing me as residing (在) at the very last (末行) of the same class as him.[17]

14. 又以尚書司勳郎盧象、小宗伯張正言，曾為歌詩，
Furthermore, because Under Secretary Lu Xiang (盧象) of the Ministry of Personnel (under the Department of State Affairs) along with Deputy Minister of the Ministry of Rites (小宗伯) Zhang Zhengyan (張正言) once composed many songs and poems about me,

15. 故敘之曰：
so Yan Zhenqing then narrated:

16. 「開士懷素，僧中之英，
"KaiShi (開士)[18] Huai Sui, distinguished among all monks,

17. 氣槩通疏，性靈豁暢。
had a cheery carefree temperament and an open receptive mind.

18. 精心草聖，積有歲時。

He devoted many years and efforts to studying the art of the "Sage of the Cursive Script(草聖)".

19. 江嶺之間，其名大著。

From the Yangtze River to the Five Ridges, his name was exceedingly well-known.

20. 故吏部侍郎韋公陟，覩其筆力，勗以有成。

Late Deputy Director of the Ministry of Personnel, the honorable Wei Zhi (韋陟), having personally observed Huai Su's penmanship skills, encouraged (勗) him to become an accomplished calligrapher.

21. 今禮部侍郎張公謂，賞其不羈，引以遊處。

Current Deputy Director of the Ministry of Rites, the honorable Zhang Wei (張謂), also treasured Huai Su's free and uninhibited spirit and so had invited Huai Su to accompany him as he toured various places.

22. 兼好事者同作歌以贊之，動盈卷軸。

There were also other enthusiasts who composed many poems and songs to praise (贊) Huai Su's works; often (動)[19], they filled up scrolls of paper.

23. 夫草稾之作，起於漢代。

Alas, the cursive script originated from the Han Dynasty (206BC-220AD).

24. 杜度、崔瑗，始以妙聞。

Du Du and Cui Yuan were among the first who scribed the wonders of the cursive script with much recognition.

25. 迨乎伯英，尤擅其美。

Later on, Boying (Zhang Zhi, 張芝) was particularly adept in expressing its beauty.

26. 羲獻茲降，虞陸相承，口訣手授。

Subsequent to Xi (Wang Xizhi, 王羲之) and Xian (Wang Xianzhi, 王獻之), there were Yu (Yu Shinan, 虞世南) as well as Lu (Lu Jianzhi, 陸柬之, and Lu Yanyuan, 陸彥遠), all of whom inherited and passed along the art of the cursive script via mnemonic cues and direct hand instructions.

27. 以至于吳郡張旭長史。

The art eventually reached Chief Secretary (or Chief Clerk) Zhang Xu of the Wu Commandery[20].

28. 雖姿性顛逸，超絕古今，而模楷精法詳，特為真正。

Although Zhang Xu held an unorthodox temperament and his artistic styles were singularly superb and unprecedented, he was able to follow the established rules thoroughly and scribed cursive scripts that were exceptionally authentic.

29. 真卿早歲常接遊居，屢蒙激昂，教以筆法。

I, Zhenqing, earlier in my life, frequently gave reception to Zhang Xu at home or away during travel, and he often inspired and taught me many calligraphic techniques.

30. 資質劣弱，又嬰物務，不能懇習，迄以無成。

As I was not very talented and was always preoccupied with worldly matters, I could not study and practice the art earnestly; ultimately (迄)[21], I did not achieve any accomplishment.

31. 追思一言，何可復得?!

Oh, how I wish I could recall a single sentence that my teacher Zhang Xu had told me in the past?!

32. 忽見師作，縱橫不群，迅疾駭人，若還舊觀。

Yet, all of a sudden, I was introduced to Master (師)[22] Huai Su's works: their aesthetics were extraordinarily dynamic and shockingly fast-paced; it was as if I had returned back in time and observed the past appearances of Zhang Xu's own works.

33. 向使師得親承善誘，函挹規模，

If only Master Huai Su had been personally mentored by Zhang Xu so that he could assimilate and take (函挹) Zhang Xu's artistic style of structure and layout;

34. 則入室之賓，捨子奚適？

indeed, who else other than Huai Su would be more suitable to becoming Zhang Xu's closest friend?

35. 嗟歎不足，聊書此以冠諸篇首。」

These all are so regrettable that my sincere exclamation here is insufficient to express my genuine feeling; so the only thing I can do now is to write this as the preamble to *A Collection of Poems Dedicated to Master Huai Su's Cursive Script* (懷素上人草書歌)."

36. 其後繼作不絕，溢乎箱篋。

Afterwards, countless commentaries by others were written to describe my cursive styles; so plentiful that they could fill up many book chests.

37. 其述形似，則有張禮部云：

In terms of the physical forms and the imposing manners (形)[23] of my cursive scripts, there was Zhang (Zhang Wei, 張謂) of the Ministry of Rites who wrote,

38.「奔蛇走虺勢入座，驟雨旋風聲滿堂。」

"Huai Sui's scripts are like swift-moving dragons and serpents decreed (勅)[24] by the Heavens to be seated promptly; his scripts are as compelling as if one is hearing the loud roars that can fill up an entire hall created from abrupt raindrops and violent swirling winds."

39. 盧員外云：「初疑輕煙淡古松，又似山開萬仞峰。」

Under Secretary Lu (盧象) wrote, "At first glance, Huai Su's cursive scripts seem akin to be puffs of light smoke hanging onto old pine trees; at the same time, they are also like mountains being

wedged to form alps that are ten-thousands of feet tall."

40. 王永州邕曰：「寒猿飲水撼枯藤，壯士拔山伸勁鐵。」
Wang Yong (王邕), Prefect of Yongzhou, wrote, "Seeing Huai Su's calligraphy can be described as if one is observing a mighty ape, during a cold winter day, hanging onto and rattling a withered vine while casually drinking water from a stream nearby; or as if one is observing a mighty warrior lifting up a mountain and straightening a piece of crooked strong iron with his bare hands."

41. 朱處士遙云：「筆下唯看激電流，字成只畏盤龍走。」
Reclusive scholar Zhu Yao (朱遙) wrote, "One singularly sees Huai Su scribes as if the lightings strikes; his scripts, once formed, are as mighty (畏)[25] as dragons moving in circles (盤龍走)."

42. 敘機格，則有李御史舟云：
With regards to narrating my artistic formats and structures (機格) [26] of my calligraphy, there was Superintendent (Imperial Censor) Li Zhou (李舟) who wrote,

43. 「昔張旭之作也，時人謂之張顛。今懷素之為也，余實謂之狂僧。以狂繼顛，誰曰不可？」
"Back then, Zhang Xu was known by the mass of his times as 'Zhang the Mad' (because of his bizarre and unconventional styles); now, considering what Huai Su has accomplished, I shall sincerely declare Huai Su as the 'Maniacal Monk'. A Manic succeeding a Mad, who can argue it's not appropriate?"

44. 張公又云：「稽山賀老粗知名，吳郡張顛曾不易。」
The honorable Mr. Zhang (Zhang Wei, 張謂) also wrote, "Even the respected elder He (He Zhizhang, 賀知章) of the Mount Kuaiji has more or less (粗)[27] heard of Hu Su's name, and Wu Commandery's Zhang the Mad (Zhang Xu) cannot replace (易)[28] Huai Su's styles."

45. 許御史瑤云：「志在新奇無定則，古瘦灕驪半無墨。醉來信手兩三行，醒後卻書書不得。」

Superintendent (Imperial Censor) Xu Yao (許瑤) wrote, "Huai Su's artistic aspirations are uniquely novel and he creates without a definite rule; his calligraphy is like an old, thin and sweaty (灕)[29] black stallion created by inkbrushes that were only half-soaked with ink. He scribes two or three rows of characters offhandedly when he is drunk but cannot reproduce the beauty of them when he sobers up."

46. 戴御史叔倫云：「心手相師勢轉奇，詭形恠狀翻合宜。人人欲問此中妙，懷素自言初不知。」

Superintendent (Imperial Censor) Dai Shulun (戴叔倫) wrote, "Huai Su's mind commands his hands and his hands guide his mind as he moves his brush to create distinctively wonderful forms and structures of all sorts of flavors and manners(勢); although his script forms are odd and bizarre, collectively they are instead aesthetically harmonious and befitting. Everyone wants to ask Huai Su about the secrets behind his wonder, yet even Huai Su himself admits he does not know how he scribes like this in the first place."

47. 語疾速，則有竇御史冀云：「粉壁長廊數十間，興來小豁胷中氣，忽然絕叫三五聲，滿壁縱橫十萬字。」

Regarding my fast pace in scribing, there was Superintendent (Imperial Censor) Dou Ji (竇冀) who wrote, "A plain white wall stood in a corridor that spanned about several tens of rooms in length. On the spur of the moment, Huai Su exhaled a small breath from his chest, suddenly let out several whimsical shouts, and then the entire wall was fully scribed with a hundred-thousand of his characters in all directions."

48. 戴公又云：「馳毫驟墨列奔駟，滿座失聲看不及。」

Mr. Dai (Dai Shulun, 戴叔倫) also wrote, "Huai Su's ink-soaked brush rapidly runs like fast chariots driven by four galloping stallions running side by side, leaving his audience speechless and

unable to trace their paths."

49. 目愚劣，則有從父司勳員外郎吳興錢起詩云：
As to seeing my unadorned nature (愚劣)[30], my uncle Qian Qi (錢起) of Wuxing (吳興)[31], who is a junior officer of the Ministry of Personnel, wrote this poem:

50.「遠錫無前侶，孤雲寄太虛。狂來輕世界，醉裏得真如。」
"The far-travelling Khakkhara staff (遠錫, a metaphor for Huai Su who had travelled to many places)[32] is like no other monk before him (前侶), he is like an isolated cloud residing within the Grand Void (太虛)[33]. When he unleashes his madness, he looks down on worldly limits; and when he is drunk, he achieves the Tathata (真如)[34]."

51. 皆辭肯激切，理識玄奧。
These were all words that were certainly and rightly (肯)[35] encouraging (激切) and they all carried deep and profound meanings.

52. 固非虛蕩之所敢當，徒增愧畏耳。
Surely, I, a shallow and ignorant (虛蕩) person, dare not shoulder all these compliments; they only serve to further my shame and apprehension.

53. 時大曆丙辰秋八月六日, 沙門懷素。
This is the time of Fall, August the sixth, Bingchen year of the Dali (AD776)[36]; Sramana (沙門)[37] Huai Su.

Footnotes

(1). In the Shu modelling version of *Huai Su's Autobiography* (蜀本懷素自叙帖), Huai Su dated the calligraphy as "大厯丙辰 (776AD)", while in the Su modelling version (蘇本懷素自叙帖) he dated it as "大厯丁巳(777AD)". For further details on these two modelling copies, please see Historical Background (II).

(2). 李肇,《唐國史補 》。上海: 上海古籍出版社, 1979, p.38。

(3).《書苑菁華》卷十八 。欽定四庫全書子部書苑菁華, 乾隆四十六年版, p.15-17。

(4). See poems such as《送外甥懷素上人歸鄉侍奉》by Qian Qi (錢起),《懷素臺歌》by Pei Shuo (裴說), and《草書歌行》by Li Bai (李白), all of which can be found in 《全唐詩》(欽定四庫全書薈要集部全唐詩, 康熙四十六年版).

(5). Strictly speaking, "Sage of the Cursive Script(草聖)" was Zhang Zhi (張芝) not Zhang Xu (張旭). Literature during or before the Tang Dynasty indicated, directly or indirectly, that "Sage of the Cursive Script(草聖)" was exclusively Zhang Zhi:

A. 衛恒 《四體書勢》:
弘農張伯英者 ... 韋仲將謂之草聖。
Hong Nong's Zhang Boying (Zhang Zhi) ... Wei Zhongjiang declared him to be the "Sage of the Cursive Script".
(interpreted by KS Vincent Poon)
Source: 衛恒 《四體書勢》.《歷代書法論文選》. 上海: 上海書畫出版社, 1979, p.16.

B. 權德輿《馬秀才草書歌》:
伯英草聖稱絕倫。
Boying (Zhang Zhi), the"Sage of the Cursive Script", was known to be unrivaled and absolutely fabulous .
(interpreted by KS Vincent Poon)
Source: 權德輿《馬秀才草書歌》.《全唐詩》 卷三百二十七. 欽定四

庫全書薈要集部全唐詩, 康熙四十六年版, p.7.

C. 李瀚《蒙求》:

伯英草聖。

Boying (Zhang Zhi) the"Sage of the Cursive Script".

(interpreted by KS Vincent Poon)

Source: 李瀚《蒙求》.《全唐詩》卷八百八十一. 欽定四庫全書薈要
集部全唐詩, 康熙四十六年版, p.5.

Some even distinct "Sage of the Cursive Script(草聖)" from
Zhang Xu by naming Zhang Xu as "Zhang the Mad(張顛)":

A. 任華《懷素上人草書歌》:

吾嘗好奇, 古來草聖無不知。豈不知右軍與獻之,

雖有壯麗之骨, 恨無狂逸之姿。中間張長史,

獨放蕩而不羈, 以顛為名傾蕩於當時。張老顛,

殊不顛於懷素。懷素顛, 乃是顛。

I have always been Interested in wonders of all kinds, nobody in the
past or present does not know the "Sage of the Cursive Script". Who
knew that Youjin (Wang Xizhi) and Xianzhi (Wang Xianzhi), although
they both displayed mighty and elegant brushstrokes of compelling
manner, regrettably lacked the beauty of the "unrestrained mania".
Standing between elegance and mania (in scribing the cursive script)
was Chief Clerk Zhang (Zhang Xu) whose styles were exceptionally
wanton and uninhibited, and so he was widely known as "the Mad"
in his days. Old "Zhang the Mad", certainly not as "Mad" as Huai Su.
Huai Su "the Mad", truly is "the Mad".

(interpreted by KS Vincent Poon)

Source: 任華《懷素上人草書歌》.《全唐詩》卷二百六十一. 欽定四庫
全書薈要集部全唐詩, 康熙四十六年版, p.4.

B. 蘇渙《贈零陵僧》:

張顛沒在二十年, 謂言草聖無人傳。

Zhang the Mad was gone for twenty years, it is generally said that
no one had conveyed the ways of the "Sage of the Cursive Script"
anymore.

(interpreted by KS Vincent Poon)

Source: 蘇渙《贈零陵僧》.《全唐詩》卷二百五十五. 欽定四庫全書薈
要集部全唐詩, 康熙四十六年版, p.8.

Today, many contend Du Fu's (杜甫) poem 《飲中八仙歌》 declared Zhang Xu was "Sage of the Cursive Script(草聖)". However, they all missed the key word "傳(convey)" in the poem 《飲中八仙歌》 by 杜甫:

張旭三杯草聖傳。
Zhang Xu, after several cups of wine, <u>conveys</u> the manner of the "Sage of the Cursive Script".
(interpreted by KS Vincent Poon)
Source: 杜甫《飲中八仙歌》.《全唐詩》 卷二百一十六. 欽定四庫全書薈要集部全唐詩, 康熙四十六年版, p.15.

Du Fu merely pointed out that Zhang Xu <u>conveyed</u> the manner of the "Sage of the Cursive Script(草聖)" when Zhang Xu was drunk. He certainly did not proclaim Zhang Xu was the "Sage of the Cursive Script(草聖)". In fact, there are no known classical literature that directly indicated Zhang Xu was the "Sage of the Cursive-Script(草聖)".

(6). In Lu Yu's (陸羽) *The Biography of Monk Huai Su of the Tang Dynasty* (《唐僧懷素傳》), a verbal exchange between Huai Su and Yan Zhenqing discussing the cursive-script calligraphic forms of "The leg of a traditional hairstick(古釵腳)" and "The paths of raindrops falling down the cracks of walls in a house (屋漏痕)" was chronicled as follows:

顏太師真卿以懷素為同學鄔兵曹弟子，問之曰：「夫草書於師授之外，須自得之。張長史覩孤蓬驚沙之外，見公孫大娘劍氣舞，始得低昂廻翔之狀，未知鄔兵曹有之乎？」懷素對曰：「似古釵腳，為草書豎牽之極。」顏公於是佇應而笑，經數月不言其書。懷素又辭之去，顏公曰：「師豎牽學古釵腳，何如屋漏痕？」懷素抱顏公腳，唱歎久之，顏公徐問之曰：「師亦有自得之乎？」對曰：「貧僧觀夏雲多奇峯，輒嘗師之。夏雲因風變化，故無常勢，又遇屈折之路，路不自然。」顏公曰：「噫！草聖之淵妙，代不絕人，可謂聞所未聞之旨也。」

The exchange could be summarized in English as follows:
Yan once asked Huai Su, "Alas, aside learning from a teacher, the art
of the cursive script must be achieved by self-introspection. Zhang
Xu (張旭) once saw a withered grass and blowing sand as well as ob-
served dancing swords to achieve his dynamic cursive script form of
vacillation and swirling. Has your teacher Wu Tong (鄔彤) been able
to achieve this?" Huai Su replied, "(My teacher told me it) Should
be like 'the leg of a traditional hairstick (古釵腳, which appears to be
straight and elegant yet strong and powerful)', such is the ultimate
form of a vertical brushstroke in the cursive script." Yan then let out
a laugh and did not discuss Huai Su's calligraphy for several months.
Afterwards, Huai Su approached Yan to say goodbye, this time Yan
asked, "You are studying to scribe the form of 'the leg of a tradi-
tional hairstick', how does that compare to the form of 'the paths of
raindrops falling down the cracks of walls in a house (屋漏痕, which
refers to a vertical line that is curvy with uneven thickness)'?" Huai
Su then held on to Yan and sighed for a very long time. Yan then
slowly asked, "Have you self-reflected and achieved the understand-
ing of the art of the cursive script?" Huai Su responded, "Whenever
I see the summer clouds that have many wonderful crests, I learn
from them. Summer clouds change with the wind, and hence their
manners are always not fixed. I have also looked at crooked roads
and paths, but these roads and paths are not natural enough." Yan
replied, "Ah! The deep wonders of the 'Sage of the Cursive Script'
now has a successor. It can be said that no one has ever heard of
what you just contended."
(summarized and interpreted by KS Vincent Poon)
Source: 《書苑菁華》卷十八. 欽定四庫全書子部書苑菁華, 乾隆四十六
年版, pp.16-17.

(7). 啟功, 「論懷素《自敘帖》墨跡本與宋刻本」。見《啟功叢
稿》。北京: 中華書局, 1999, pp.117-119。

(8). 傅申, 「確證《故宮本自敘帖》為北宋映寫本──從《流日半
卷本》論《自敘帖》非懷素親筆」。《典藏古美術》, 第158期,
2005年11月, pp. 86-132。

(9). See (7).

(10)

Fig.1

A portion of the Shu version of *Huai Su's Autobiography*

(蜀本 懷素自叙帖)

Fig.2

A portion of the Su version of *Huai Su's Autobiography*

(蘇本 懷素自叙帖)

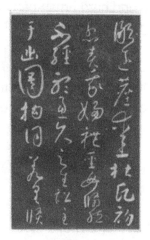

Fig.3

A portion of Huai Su's *Sheng Mu Tie* (懷素聖母帖)

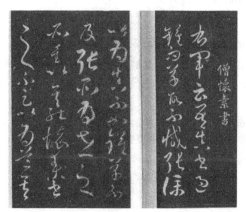

Fig.4

A portion of Huai Su's *Guo Zhong Tie* (懷素過鍾帖)

It is evident that the Su Version of the *Autobiography* (Fig.2) appears to be less consistent with the styles observed in Huai Su's other works such as *Sheng Mu Tie* (聖母帖) (Fig.3) and *Guo Zhong Tie* (過鍾帖) (Fig.4). The Su version, although offers dramatically different sizes of each character, lacks the dynamic and variations of each brushstroke within one character; it is as

if it is written via a solid and hard brush-pen and so each stroke is comparatively boring and un-lively. The Shu Version (Fig.1), however, carries more of the same dynamic and variations in each brushstroke as observed in *Sheng Mu Tie* and *Guo Zhong Tie*. It is hence clear that the person who scribed the Shu version had a higher level of calligraphic skill than the person who scribed the Su version.

(11). 董誥編,《全唐文》卷三三七。欽定全唐文, 嘉慶十九年版, p.13。

(12). "杖錫" refers to the Khakkhara, a "sounding staff" held by a Buddhist monk, see《佛學詞典》, 香港:菩提學社, 出版年份缺, p.511.

(13). "上國" means Tang Dynasty's capital Chang'an (長安), which is currently Xi'an (西安).

(14). "錯綜" here means "將資料交叉運用並綜合參考 (take reference to many information)" as in the *Book of Han - Afterword and Family History II* (《漢書》卷一百下敘傳下) :

錯綜群言 , 古今是經 , 勒成一家 , 大略孔明。
Source: 班固《漢書》. 香港:中華書局, 1970, p.4257.

(15). In the Su version, it is "魚賤絹素".

(16). "流" here means "等級(class/league)" in this context , see 《漢典》.

(17). "末行 (at the end of the row)" is a self-effacing statement and it refers to "名次位於行列的末尾(last in the group of the same level)" as seen in *Book of Jin -Biography of Wang Xizhi* :

然古人處閭閻行陣之間 , 尚或干時謀國 , 評裁者不以為譏 , 況廟大臣
末行 , 豈可默而不言哉 !

Source: 房玄齡《晉書》卷八十王羲之列傳. 北京:中華書局 ，1974
, p.2097.

Hence, "末行" here has nothing to do with "the end of a piece
of calligraphy", which is a mistake commonly observed in many
vernacular Chinese interpretations.

"許在末行" was a direct response to Line 12; Huai Su narrated
that Yan Zhenqing, who was considered to be at the class of
great calligraphers, had regarded Huai Su was at the same class
as he was.

(18). "開士 (KaiShi)" is a Buddhist term that is akin to bodhisattva
(菩薩), a person (士) who is enlightened and can enlighten others
(開). See《佛學詞典》, 香港:菩提學社, 出版年份缺, p.410.

(19). "動" here means "往往", see中央研究院 《搜詞尋字》.

(20). The Wu Commandery in Tang Dynasty is currently located
in an area within the borders of Jiangxu (江蘇) and Zhejiang (浙
江)provinces.

(21). "迄" here means "始终(ultimately)" , see 《漢典》.

(22). "師" here refers to "法師(Master)", a specialized term used in
Buddhism to describe a highly respected monk.

(23). "形" here refers to "manners imposed by the workings of a
brush (形勢/筆勢)" in additional to "forms of characters (字形)".

(24). "勅" means "command/decrees", please see *Kangxi Diction-
ary* (《康熙字典》)"勅".

In the Shu version, the character is "勅" not "勢" that is seen
in the Su version. Judging solely on the wording of the entire
phrase "奔蛇走虺勅入座", the position occupied by "勅" should be

a verb, and so "勢", which can only represent a noun, makes no sense. Hence, it is likely that Huai Su originally wrote "勅" and the person who created the Su version made an error in scribing it.

(25). "畏" here means "威(mighty)", please see *Kangxi Dictionary* (《康熙字典》)"畏".

(26). "機格" means "規格，格式(format/structure)", see 《漢典》.

(27). "粗" here means "略(more or less)", please see *Kangxi Dictionary* (《康熙字典》)"粗".

(28). There is considerable debate on whether the last character of the phrase "吳郡張顛曾不易" written in the *Autobiography* is "易" or "面". The character should be "易" based on the following two reasons:

I. Despite the character in the Su version can be interpreted as "易" or "面",

the character in the Shu version is clearly "易":

This is supported by 《行草大字典》, which clearly indicates both characters in the Shu and Su versions are "易":

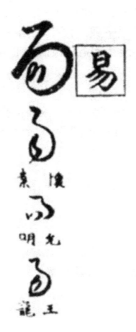

Source: 《行草大字典》, 北京：中國書店，1981年影印.

II. Some contend that "吳郡張顛曾不面" means "吳郡張顛也不曾見過懷素一面(Wu Commandery's Zhang the Mad had never met Huai Su before)", but this is unreasonable since this part of the *Autobiography* is about praising Huai Su's calligraphic achievements. Whether Huai Su had met Zhang Xu is certainly irrelevant in this context.

Therefore, the correct sentence should be "吳郡張顛曾不易". Taken together with the preceding sentence, the entire phrase is "稽山賀老粗知名，吳郡張顛曾不易" which means "稽山賀知章也略知其名(懷素)，連吳郡張顛也不能替代他(懷素)的風格" and is translated to English here as such.

Note "曾" here means "也(also)", and "易" means "替代(replace/substitute)", see 中央研究院 《搜詞尋字》.

(29). "灕" here means "水滲 (water seeping through)", see *Kangxi Dictionary* (《康熙字典》)"灕". Since this "灕" was used here as an adjective to describe a horse, it should be interpreted as "sweaty".

(30). "愚劣" literally means "foolish and inferior". In this context, it should be interpreted as a self-effacing statement for one's original "unrefined and unadorned nature".

(31). Wu Xing is currently Hu Zhou (湖州) of Zhejiang (浙江) province.

(32). "遠錫 (the far-traveling Khakkhara staff)" was extracted from the poem 《送外甥懷素上人歸鄉侍奉》 by Qian Qi (錢起):

釋子吾家寶，神清慧有餘。
能翻梵王字，妙盡伯英書。
遠鶴無前侶，孤雲寄太虛。
狂來輕世界，醉裡得真如。
飛錫離鄉久，寧親喜臘初。
故池殘雪滿，寒柳霽煙疏。

壽酒還嘗藥，晨餐不薦魚。

遙知禪誦外，健筆賦閒居。

Source: 錢起《送外甥懷素上人歸鄉侍奉》.《全唐詩》 卷二百三十八.
欽定四庫全書薈要集部全唐詩, 康熙四十六年版, p.19.

(33). "太虛(Grand Void)" is a term in Taoist philosophy that describes the ultimate form of "Tao(道)" which governs, supports, and gives birth to all things in the Universe. In *Zhuang Zhi – Outer Chapters - Knowledge Rambling in the North* (《莊子•外篇•知北遊》), James Legge translated "太虛" as "Grand Void":

無始曰：「有問道而應之者，不知道也。雖問道者，亦未聞道。道無問，問無應。無問問之，是問窮也；無應應之，是無內也。以無內待問窮，若是者，外不觀乎宇宙，內不知乎太初，是以不過乎崑崙，不遊乎太虛。」

No-beginning (further) said, 'If one ask about the Tao and another answer him, neither of them knows it. Even the former who asks has never learned anything about the Tao. He asks what does not admit of being asked, and the latter answers where answer is impossible. When one asks what does not admit of being asked, his questioning is in (dire) extremity. When one answers where answer is impossible, he has no internal knowledge of the subject. When people without such internal knowledge wait to be questioned by others in dire extremity, they show that externally they see nothing of space and time, and internally know nothing of the Grand Commencement. Therefore they cannot cross over the Kun-lun, nor roam in the Grand Void.'
– translated by James Legge in *Sacred Books of the East*.

(34). "真如(Tathata)" is a Buddhist term describing "true state of things" or "suchness". "真" is "true, real, ultimate", 如 is "constant, unchanging", see 《佛學詞典》, 香港:菩提學社, 出版年份缺, p.340. In this context, it alluded to Huai Su's calligraphy had already transcended to a level that was not constrained by the inconcrete and ever-changing physical world.

(35). In the Shu version, the character is "肯", which in this context means "certainly and rightly (能夠/恰好)", see 中央研究院 《搜詞尋字》. In the Su version, the character is "旨(thesis/gist)".

"激切" means "激勵 (encouraging)", see 中華民國教育部《重編國語辭典修訂本》.

(36). "Bingchen year of the Dali(大曆丙辰)" refers to the eleventh-regnal year of Tang Emperor Daizong's (唐代宗) reign.

(37). "沙門(Sramana)" is "佛教的出家人(a person who vows to live under strict obedience to the teachings of Buddhism)" and so usually refers to a Buddhist monk. See 《佛學詞典》, 香港:菩提學社, 出版年份缺, p.244.

Modelling of *Huai Su's Autobiography*
by KS Vincent Poon

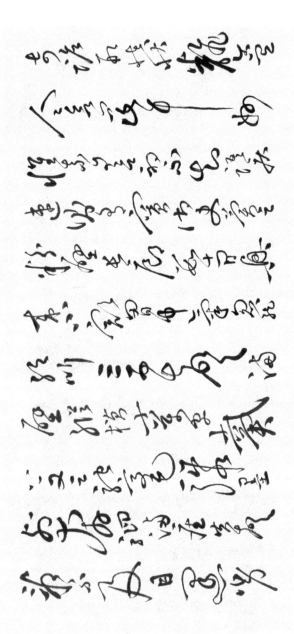

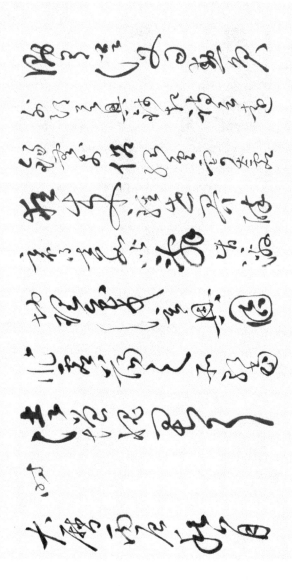

Bibliography

English

Chavannes, Édouard, *"Les pays d'Occident d'après le Heou Han chou"*. *T'oung pao, vol. 8*, 1907.

Ebrey, Patricia, *"Later Han Stone Inscriptions"*. *Harvard Journal of Asiatic Studies, vol. 40, no. 2*, 1980.

Forke, Alfred, *Lun-heng, Part 1. Philosophical Essays of Wang Ch'ung*. Leipzig: TTO Harrassowitz, 1907.

Legge, James, *The life and works of Mencius*. London : Trübner, 1875.

Legge, James, *Sacred Books of the East, Volume 3, The Shû king*, edited by Max Mueller. Oxford: Clarendon Press , 1879.

Legge, James, *Sacred Books of the East, The Texts of Taoism*, edited by Max Mueller. Oxford: Clarendon Press , 1891.

Legge, James, *Sacred Books of the East, Volume 16, The Yî king*, edited by Max Mueller. Oxford: Clarendon Press, 1891.

Legge, James, *Sacred Books of the East, Volume 27, The Li king*, edited by Max Mueller. Oxford: Clarendon Press , 1885.

Lin, Yutang, *The Importance of Understanding* 古文小品譯英. Great Britain: Heinemann, 1961.

Poon, KS Vincent & Poon, Kwok Kin, *A Narrative on Calligraphy by Sun Guoting* 英譯書譜. Toronto: The SenSeis, 2018.

Chinese

上海書畫出版社,《歷代書法論文選》。上海: 上海書畫出版社, 1979。

王充,《論衡》。欽定四庫全書子部論衡, 乾隆四十三年版。

王安石,《王臨川集》。上海: 商務印書館, 1928。

王弼注、 孔穎達疏,《周易注疏》。上海: 中華書局據阮刻本校刊, 1936。

王慎中,《遵巖先生文集》。明隆慶五年版。

孔安國,《尚書孔傳》。台北: 新興書局,1964。

司馬貞,《史記索隱》。 欽定四庫全書史部史記索隱, 乾隆四十六年版。

司馬遷,《史記》。 香港: 廣智書局 , 出版年份缺。

朱久瑩選輯，《歷代法書選輯·漢曹全碑》。高雄: 大衆書局, 1973。

朱熹，《四書集註》。香港: 太平書局，1968。

朱彝尊，《經義考》。欽定四庫全書史部經義考，乾隆四十六年版。

李延壽，《南史》。北京: 中華書局, 1975。

李長路，王玉池，《王羲之王獻之年表與東晉大事記》。重慶: 重慶出版社, 1992。

李肇，《唐國史補》。上海: 上海古籍出版社, 1979。

房玄齡，《晉書》。北京:中華書局, 1974。

紀曉嵐，《閱微草堂筆記》。上海: 上海春明書店, 出版年份缺。

韋昭注，《國語》。欽定四庫全書薈要史部國語，乾隆四十二年版。

班固，《漢書》。香港:中華書局, 1970。

袁康，《越絕書》。欽定四庫全書史部越絕書，乾隆四十六年版。

啟功，《啟功叢稿》。北京: 中華書局, 1999。

范曄，《後漢書》。香港:中華書局, 1971。

陳伯君校注，《阮籍集校注》。北京: 中華書局, 1987。

陳思，《書苑菁華》。欽定四庫全書子部書苑菁華，乾隆四十六年版。

陳壽，《三國志》。臺北: 中華書局, 1968。

陳襄民，《五經全譯·易經》。河南: 中州古籍出版社, 1993。

曹寅編，《全唐詩》。欽定四庫全書薈要集部全唐詩，康熙四十六年版。

張丑，《清河書畫舫》。欽定四庫全書子部清河書畫舫，乾隆五十二年版。

張彥遠，《法書要錄》。北京: 人民美術出版社, 1984。

張高寬等編，《宋詞大辭典》。瀋陽: 遼寧人民出版社, 1990。

陶宗儀，《書史會要》。上海: 上海書店, 1984。

郭慶藩，《莊子集釋》。北京: 中華書局, 1985。

黃本驥編，《顏魯公全集》。上海: 上海仿古書店, 出版年份缺。

葉盛，《水東日記》。北京:中華書局，1980。

傅申，「確證《故宮本自敘帖》為北宋映寫本——從《流日半卷本》論《自敘帖》非懷素親筆」。《典藏古美術》，第158期, 2005。

賈誼,《新書》。 鴻文書局, 光緒十九年版。

維新史料編纂事務局 編,《維新史》。 東京: 維新史料編纂事務局, 昭和十六年 (1941)。

臧勵龢選註,《戰國策》 。上海:商務印書館, 1933。

劉昫,《舊唐書》。臺灣: 臺灣中華書局, 1971。

劉勰, 《文心雕龍》。上海: 商務印書館 , 1937。

歐陽修,《新唐書》。北京: 中華書局, 1975。

董誥編,《全唐文》。欽定全唐文, 嘉慶十九年版。

賴炎元編,《韓詩外傳今註今譯》。台北: 商務印書館, 1979 。

Dictionary

梁披雲編 , 《中國書法大辭典》。廣東: 廣東人民出版社,1991。

劉正成編, 《中國書法鑒賞大辭典》。 北京: 大地出版社 , 1989。

《中國書法大字典》。台北: 大通書局, 1973 。

《康熙字典》。上海:上海書店, 1985。

《佛學詞典》。香港:菩提學社, 出版年份缺。

《行草大字典》。北京 : 中國書店 , 1981年影印。

Websites

中央研究院《搜詞尋字》 。 words.sinica.edu.tw/sou/sou.html 。

中華民國教育部《重編國語辭典修訂本》 。 dict.revised.moe.edu.tw/cbdic/。

《漢典》 。 www.zdic.net 。